LE CORBUSIER. ARCHITECT OF BOOKS

CATHERINE DE SMET

LARS MÜLLER PUBLISHERS

Le Corbusier at his work-table in his apartment
on Rue Jacob, Paris
Circa 1930

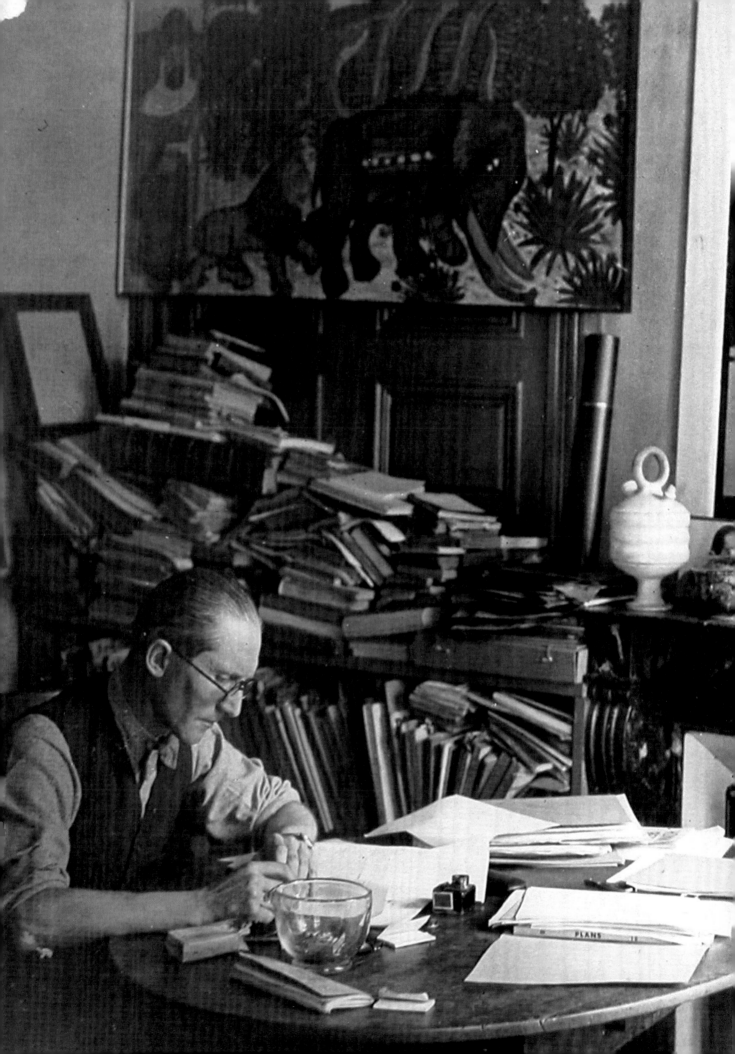

MAN OF LETTERS, MAN OF BOOKS

Le Corbusier is well known as an architect, urban planner, and entrepreneur, and also as a publicist, theorist, writer, and photographer, and even as an artist who produced drawings, paintings, and sculpture. Yet there is one activity, related to all these others but not subsumed by any of them, to which Le Corbusier tirelessly devoted himself right up to his death in 1965: the production of books. This activity merits greater attention since Le Corbusier conceived of his books not only as intellectual projects but also as concrete works that he intended to master from A to Z. The quantity of books he published is revealing in itself: thirty-five titles (according to the bibliography that concludes his last book, *L'Atelier de la recherche patiente*[I]), not counting his contributions to general books on his work nor his countless articles. And then there were the editorial projects that never came to fruition–Le Corbusier constantly envisaged various new publishing projects, as his archives reveal.

We know how important literary culture was to the man who presented himself as a "man of letters" (duly inscribed on his identity card issued in the 1930s). The importance of the reading he did as a youth and the influence of intellectuals and writers throughout his adult career never faded. On numerous occasions he expressed his literary affinities, even in his artwork–for example, he incorporated a line from Mallarmé, "Garder mon aile dans ta main" (Hold my wing in your hand) into his fresco for the Swiss Pavilion at the Cité Universitaire in Paris (1948). This same image of a winged figure also inspired the cover of his booklet *Poésie sur Alger*[II] (1955). Le Corbusier, who had himself been tempted by a literary calling, thus encouraged a constant back-and-forth movement in his work between textual space and visual field. Books represented an essential link between writing and art for a creative artist in search of unity, and they also played a role as a visual motif in Le Corbusier's paintings. For example, *La Cheminée* (The Mantelpiece), painted in 1918 and allegedly constituting the start of his artistic career (according to the myth Le Corbusier constructed for himself), features two books stacked next to a cube, where they thus assume full significance as "volumes."

The visual and physical impact of a book was sufficiently important to Le Corbusier to spur him to meddle in questions of layout right from his first publications in the 1920s, in which he intervened concerning decisions on format, paper, typeface, and cover design. "This book," he wrote of *Vers une architecture*[III] (1922) "draws its expressiveness from the use of new methods; its magnificent illustrations generate a parallel, highly powerful

I *Creation is a Patient Search*, trans. James Palmes (New York: Praeger, 1960).
II Poetry Upon Algiers
III *Towards a New Architecture*, trans. Frederick Etchells (New York: Payson and Clarke; London: John Rodker, 1927).

argument alongside the text. This new conception of a book, using the explicit, revelatory argument of illustrations, enables the author to avoid feeble descriptions: facts leap to the reader's eye through the power of imagery."[1]

In 1958, when Vincent & Fréal republished *Vers une architecture* in a context in which a much broader French public was sensitive to issues of layout than had been the case back in 1923, Le Corbusier sought to underscore – thirty-five years after the fact – how advanced his views had been. "The layouts of my articles (assembled all together) sparked astonishment and indignation among the printers (at Arrault's in Tours), who said, referring to me and their trade (typography), 'He's mad.' Back then! Regarding the typography! 'Madman!'"[2] Through the implicit comparison between this early reputation for "madness" and the later, notorious label of "nutcase" (*fada*) applied to him in Marseille in the 1950s when he built the first apartment block known as Unité d'Habitation, Le Corbusier was underscoring the constancy of his nonconformist attitude ("Back then!") and the breadth of his struggle, ranging from page layout to architecture. A few years earlier, he had expressed the analogy between these two activities in a more direct fashion in the foreword to his book *Le Modulor* (1950): "The term architecture here refers to the art of building [as well as] the typographical art of newspapers, magazines, and books."

By explicitly linking "typographical art" to "the art of building" in *Le Modulor*, Le Corbusier was honoring a long tradition – the architectural metaphor has dwelled in books since well before the invention of printing, whether through the textual component, internal organization, or physical structure. Le Corbusier exploited this historic connection to develop his own, unique version of it. When emphasizing the fundamental importance of written texts to Le Corbusier's conception of architectural space, Françoise Choay stressed that although Le Corbusier's publications represent "the most abundant, most widely disseminated, and most extensively read literature on town planning," they were not, overall, ground-breaking in nature but tended instead to reflect existing trends.[3] For my part, I have tried to view this issue from another angle – not by "prejudicing the words" as Choay did, but by prejudicing what Paul Valéry called a book's "second virtue": its quality as an object, its "physique."[4] I have done so in order to test a simple hypothesis, one that Le Corbusier himself formulated: "Much of L.C.'s creative work was developed in his books."[5]

All documents located in the archives of the Fondation Le Corbusier are indicated in the footnotes by the abbreviation FLC, followed by the shelf-mark.

1 Advertising document, FLC, B2-15-17.
2 FLC, B2-15-192 (manuscript of the preface to the new edition of *Vers une architecture*).
3 Françoise Choay, *La Règle et le Modèle* (Paris: Seuil, 1996, 2nd ed.), 317.
4 Paul Valéry, "Les deux vertus d'un livre" [1926], reprinted in *Œuvres* (Paris: Gallimard, La Pléiade, 1977), II: 1246-1250.
5 *L'Atelier de la recherche patiente*, 299.

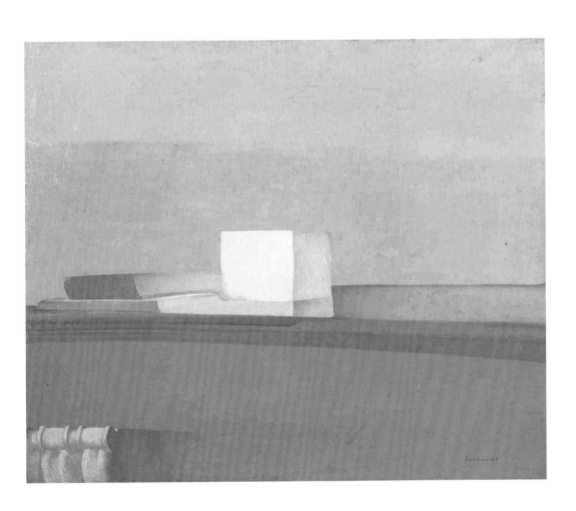

La Cheminée / The Mantelpiece, 1918
Oil on canvas
600 × 730 mm

THE PUBLISHING EDIFICE

The cover of *Étude sur le mouvement d'art décoratif en Allemagne*, 1912
200 × 165 mm

The cover (dust jacket) of *Mein Werk / L'Atelier de la recherche patiente*, 1960
280 × 220 mm

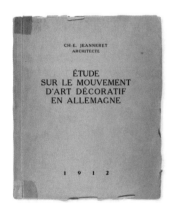

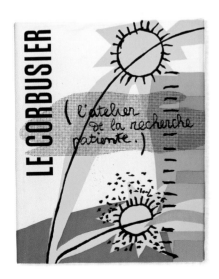

THE PRINTED ŒUVRE

A NONSTOP PROCESS

For Le Corbusier, the production of books was part of an almost nonstop publishing process. The period covered here begins with the 1912 publication of a booklet titled *Étude sur le mouvement d'art décoratif en Allemagne*.[IV] The young Charles-Édouard Jeanneret – who only later adopted the pseudonym of "Le Corbusier" – was then twenty-five years old yet already a practicing architect (his first villa, built in his home town of La Chaux-de-Fonds, Switzerland, dates back to 1906–1907). His final book, *L'Atelier de la recherche patiente*, was published five years before his death in 1965 at Cap Martin, followed by fully-developed new editions of earlier works and by various never-completed projects. There were also several posthumous publications.

Cap Martin, where Le Corbusier elaborated many of his later books, was a village on the French Riviera. There he had built in 1952 a seaside home known as Le Cabanon, a minimal hut with Modulor proportions designed for vacations – always hard-working – with his wife, Yvonne. And that is where he died on August 27, 1965, during his daily dip in the Mediterranean Sea, at the age of seventy-seven. Widowed eight years earlier, he had continued to work tirelessly while seriously envisaging his own death, as witnessed by his plans for the foundation that would bear his name. Le Corbusier was well aware that books constituted a crucial medium for disseminating his work, and so publishing questions were central to his concerns during that summer of 1965.

Stimulated by the man he had chosen as his special partner in this sphere, the young graphic artist and publisher Jean Petit (with whom Le Corbusier had been working for some ten years already), he spent the month of July in his Paris apartment on Rue Nungesser-et-Coli, rereading the text of *Voyage d'Orient*,[V] written in 1911, which he was now planning to publish. During that same month he signed several contracts and agreements with Petit, bearing on an astonishing number of titles: twenty-eight in total, not counting other projects that had already been the subject of agreements the preceding year. Sixteen of these titles concerned a series of small, inexpensive paperbacks designed to make texts by Le Corbusier – new and old – "available to a young readership," which became the leitmotif of an

IV A Study of the Decorative Art Movement in Germany
V *Journey to the East*

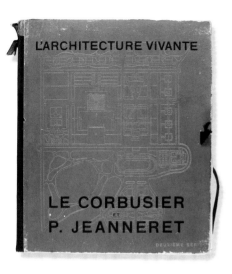
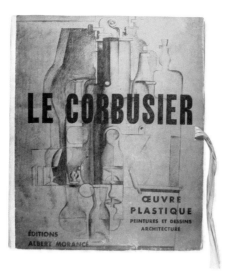

6 Agreement and contract between Le Corbusier and Jean Petit dated July 5 and July 17, 1965 (Jornod Archives, Geneva). Only two of the sixteen planned paperbacks were published in 1965 and 1966, under an imprint called Micro-Carnets Forces Vives: *Textes et dessin pour Ronchamp* and *L'urbanisme est une clef*. The third volume in the series, *Mise au point*, was probably a posthumous collage of texts made by Petit (despite indications to the contrary in the book itself). Petit's biography was not published until 1970, under the title of *Le Corbusier lui-même* (Geneva: Éditions Rousseau), but an annotated dummy attests to the fact that Le Corbusier had indeed corrected the initial draft (Jornod Archives).
7 Arthur Rüegg, *Polychromie Architecturale: Le Corbusier's Color Keyboards from 1931 and 1959* (Basel/Boston/Berlin: Birkhäuser, 1997).

VI Living Architecture
VII *The Complete Architectural Works* (Zurich: Les Éditions d'Architecture Erlenbach, 1935–65).
VIII *The Poem of the Right Angle*, trans. Kenneth Hylton (Paris: Fondation Le Corbusier/Connivances, 1989).
IX *The Chapel at Ronchamp*, trans. D. Cullen (New York: Praeger; London: Architectural Press, 1957).
X *The Final Testament of Père Corbu*, trans. Ivan Zaknic (New Haven/London: Yale University Press, 1997).

architect always keen to address the next generation. One of the books was a biography written by Petit, which Le Corbusier would reread and correct – as stipulated in the contract – during his summer stay in Cap Martin.[6]

A SPRAWLING, COMPOSITE OUTPUT

This publishing fever, apparently linked to a feeling of urgency spurred by the certainty of approaching death, in fact differed little from the fever that seemed to grip Le Corbusier throughout his life. The volumes conceived and written by the architect were part of a web of a great number of other publications, which for that matter often fed into his books in the form of successive salvage and reuse.

A large role was played not only by Le Corbusier's numerous articles, but also by books on his architecture (produced with his partner and relative, Pierre Jeanneret, up to 1940), to which he largely contributed even though he was neither author nor editor. These included the seven volumes of *L'Architecture vivante*[VI] (1927–1936, plus a 1938 book titled *Le Corbusier: Œuvre plastique*) and eight volumes of *Œuvre complète*[VII] (1929–1969). Then there were exhibition catalogues and various sets of lithographs, such as the portfolio called *Le Poème de l'angle droit*[VIII] (1955).

Two hard-to-categorize albums titled *Claviers de couleur* (Basel: Salubra, 1931 and 1959) contained samples of wallpaper designed by Le Corbusier. They provided clients with the opportunity to coordinate colors by using a "color keyboard" and a little viewing window. These albums were directly related to Le Corbusier's architectural and artistic œuvres, being a development of the palette resulting from his dual experience in handling color. It is worth noting that this link took the concrete form of an object that resembled a book even though it functioned in an exclusively visual fashion.[7]

The books published in the 1950s and 1960s by Petit under the imprint of Cahiers Forces Vives – from *La Chapelle Notre-Dame-du-Haut*[IX] in 1956 to *Mise au point*[X] in 1966 – betray a significant delegation of tasks by an aging Corbusier concerned with consolidating his publishing legacy. Furthermore, new editions of earlier works – which only became a reality after 1950, despite several earlier efforts by Le Corbusier – offer valuable insight into the author's view of his previous books, thanks to the additions, subtractions, and changes made. Finally, there were many plans for books that were never published. Major vestiges of these projects have sometimes survived;

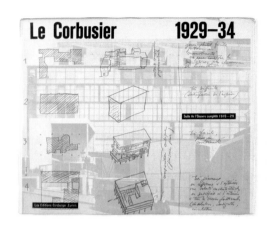

The cover of *Le Corbusier et Pierre Jeanneret: Œuvre complète 1910–1929*, with Max Bill's 1937 dust jacket
Willy Boesiger & Oscar Stonorov (editors), 1929
232 × 290 mm

The cover of *Le Corbusier et Pierre Jeanneret: Œuvre complète 1929–1934*, with Max Bill's 1934 dust jacket
Willy Boesiger (editor), 1934
232 × 290 mm

8 *Les Plans de Paris* 1956-1922, 107.
9 Darlene Brady, *Le Corbusier: An Annotated Bibliography* (New York/London: The Garland Publishing, 1985); Jacques Lucan (ed.), *Le Corbusier, une encyclopédie* (catalogue published for the exhibition titled *L'aventure Le Corbusier*, held at the Centre de Création Industrielle in the Georges Pompidou Center, Paris (Paris: Éditions du Centre Pompidou-CCI, 1987).
10 Petit, *Le Corbusier lui-même* (Geneva: Éditions Rousseau, 1970).

XI *The Three Human Establishments,* trans. Eulie Chowdhury (Chandigarh: Punjab Gov't. Town & Country Planning, c. 1979).

others make it possible to measure the scope of things that Le Corbusier had hoped to explore, which is only partly suggested by his bibliography. All these documents ultimately shed crucial light on the architect's approach to publishing.

BIBLIOGRAPHIC HESITATIONS

"I've written over forty-five books," claimed Le Corbusier in 1956.[8] A more reasonable figure comes from the selection that he proposed in 1960 in *L'Atelier de la recherche patiente*, which numbers thirty-five titles. This rigorous inventory constitutes a kind of natural bibliographic corpus, for Le Corbusier clearly distinguished books from periodicals, the latter being excluded from the list (except for the 1939 and 1950 issues of *Le Point*). He also excluded two volumes edited and published by Jean Petit (*La Chapelle Notre-Dame du Haut*, 1956 and *Le Poème électronique*, 1958). Finally, he eliminated the brochures titled *Mundaneum* (1928) and *Requête auprès de la Société des Nations* (1931). This selection process was significant because it included only publications that took the form of a book, the implication being that the responsibility of the author was for the whole book rather than for the text alone. Although this bibliography of 1960 acknowledged the coauthors of three of the titles–Amédée Ozenfant for *Après le cubisme* (1918) and *La Peinture moderne* (1925), and François de Pierrefeu for *La Maison des hommes* (1942)–it completely ignored the collective nature of a publication like *Les Trois Établissements humains*,[XI] which was initially signed by ten different authors. The republication of this book during Le Corbusier's lifetime, under his own name, made it possible for him to forestall any question of paternity (just as the republication of *La Charte d'Athènes* allowed him to claim a work that had initially been published with no indication of author).

As of this writing, there exists no authoritatively comprehensive bibliography of Le Corbusier's publications; the most complete sources are the bibliography drawn up by Darlene Brady in 1985 and the one found in the catalogue published by the Georges Pompidou Center in 1987.[9] A list compiled in 1970 by Jean Petit numbers fifty-six entries, plus an additional seven "illustrated books published in limited editions."[10] The bibliography posted at the internet site of the Fondation Le Corbusier includes forty-eight entries, while the extensive bibliography of "writings" in the Pompidou catalogue of 1987 covers almost all of Le Corbusier's written output and numbers over three hundred items.

Catalogue of the traveling exhibition titled
«Exposition des capitales», cover, 1957–1960
225 × 155 mm

Exhibition catalogue, cover
Musée National d'Art Moderne, Paris, 1962
210 × 160 mm

Exhibition catalogue, cover
(printed by Fernand Mourlot)
Musée de Lyon, 1956
240 × 180 mm

Exhibition catalogue, cover
Kunsthaus, Zurich, 1938
269 × 199 mm

A BOOKISH LIFE

After spending two years in Paris, the young Charles-Édouard Jeanneret returned briefly to Switzerland and then set out for Germany in April 1910. He remained there for a year or so, before traveling further east. While in Germany, at the suggestion of Charles L'Éplattenier – his former teacher at the art school in La Chaux-de-Fonds who also helped him obtain a project grant – Jeanneret drew up a report on German "organization and professional training in the arts and crafts, and the design, manufacture, and sale of artistic products."[11] This study provided the young man with an opportunity to observe the innovative approach to book design adopted by German professionals, and his report notably mentioned the outstanding creative work done by Peter Behrens (in whose workshop Jeanneret spent several months). Behrens was responsible for all creative design at the electricity company AEG, ranging from architectural conception to typographical decisions, providing a crucial model for the future Le Corbusier. The young man's first book, *Étude sur le mouvement d'art décoratif en Allemagne*, would also be the last to be published in his home town. His second publication, *Après le cubisme*, would appear at the end of 1918 in Paris, where he had set up permanent residence.

Après le cubisme,[XII] coauthored by the painter Amédée Ozenfant, was a manifesto in favor of the Purist movement in art. Jeanneret's encounter with Ozenfant in 1917 turned out to be decisive, for it spurred the young man's painterly ambitions. In 1920, also in collaboration with Ozenfant and a literary figure called Paul Dermée, he launched the publication of a review called *L'Esprit nouveau*. The periodical ran for five years and also spawned an imprint of the same name hosted by publisher Georges Crès, the first five volumes of the series being reprints of articles from the magazine. Among the eight titles by Jeanneret/Le Corbusier published by Crès, from *Vers une architecture* in 1923 to *Croisade* in 1933, there was a second book on painting coauthored with Ozenfant, *La Peinture moderne*[XIII] (1925). Yet even though he assiduously pursued his artistic activities, most of Le Corbusier's books would be devoted, up till the end of the Second World War, to architectural and urban-development issues, to his work as a builder and to the various projects he was engaged in from Paris to Moscow, from Rio to Algiers, and from Geneva to New York. Although he described, using an architectural metaphor, *Urbanisme*[XIV] and *L'Art décoratif d'aujourd'hui*[XV] as the "left and right wings" of his famous *Vers une architecture*, it was this latter title of 1923 that earned him his reputation. The numerous editions that followed shortly after its initial publication – which already entailed a first

11 Charles-Édouard Jeanneret, *Étude sur le mouvement d'art décoratif en Allemagne* (La Chaux-de-Fonds: Haefli & Cie., 1912), 5.

XII "After Cubism," translation published in Carol Eliel, *L'Esprit Nouveau: Purism in Paris 1918–1925* (New York: Abrams, 2001).
XIII Modern Painting
XIV *The City of Tomorrow and Its Planning*, trans. Frederick Etchells (New York: Payson & Clarke, 1929).
XV *Decorative Art of Today*, trans. James I. Dunnett (Cambridge, Mass.: MIT Press, 1987).

Le Corbusier with *La Ville radieuse*
Circa 1935

print-run of 3,000 copies, according to the contract of 1922 – allowed Crès to advertise it as a "hit" book. And it was also a hit beyond French borders. By 1928, the book had been translated into both German and English, and Le Corbusier's concept of a "machine for living," his lyrical definition of architecture ("a skillful, accurate, magnificent play of volumes in the light"), and his bold comparison of automobiles to Greek temples all resounded around the world.

Once the Crès publishing firm went bankrupt, Le Corbusier came to an agreement with a publishing house called Architecture d'Aujourd'hui, where he launched an imprint known as L'Équipement de la Civilisation Machin-iste (Equipping the Machine-Age Civilization). Two of his titles appeared under this imprint, *La Ville radieuse*[XVI] (1935), a vaguely indigestible com-pilation on urban development ("a summa of everything I've ever published on the question"[12]), and *Des Canons, des Munitions ? Merci ! Des Logis... SVP*[XVII] (1938), which was an "album" designed to accompany Le Corbusier's pavilion at the 1937 World's Fair, the Pavillon des Temps Nouveaux. Despite a plan to publish other authors under this imprint, only one work not authored by Le Corbusier ever saw the light of day, a collective report on the fifth CIAM convention (International Congress of Modern Architecture), titled *Logis et loisirs*.[XVIII]

During this period, The Studio Ltd. in London commissioned Le Corbusier to write *Aircraft* (1925), a timely book that glorified aviation. Income from the publication offset some of the financial burden of *La Ville radieuse*, which had been designed and printed at Le Corbusier's own expense. He also wrote another book, published by Plon, recounting his recent trip across the United States, *Quand les Cathédrales étaient blanches*[XIX] (1937). In addition, he authored a booklet on urban planning in the new era ("Le lyrisme des temps nouveaux and l'urbanisme"), published as a special issue of the review *Le Point*.

In the seven years between 1940 and 1946 Le Corbusier managed to pub-lish nine books despite the problems encountered by publishers in war-torn France, which testifies to the architect's tenacity (the archives are brimming with evidence of his harassment of publishers during this period). The two books that appeared in 1946, *Manière de penser l'urbanisme*[XX] (published by Les Éditions de l'Architecture d'Aujourd'hui) and *Propos d'Urbanisme*[XXI] (Bourrelier) consolidated and extended the work he had begun during the war years. This unparalleled publishing output corresponds to his intense

12 Letter from Le Corbusier dated November 24, 1933 (FLC, B2-1-156).

XVI *The Radiant City: Elements of a Doctrine of Urbanism to Be Used as the Basis of Our Machine-Age Civilization*, trans. Pamela Knight, Eleanor Levieux, and Derek Coltman (London: Faber and Faber; New York: Orion Press, 1967).
XVII Cannons and Ammunition? No, Thanks. Housing, Please!
XVIII Housing and Leisure Activities
XIX *When the Cathedrals Were White: A Journey to the Country of Timid People*, trans. Francis E. Hyslop, Jr. (New York: Raynal & Hitchcock, 1947; London: Routledge, 1948).
XX *Looking at City Planning*, trans. Eleanor Levieux (New York: Grossman, 1971).
XXI *Concerning Town Planning*, trans. Clive Entwistle (London: Architectural Press, 1947).

activity during that time, from his rapprochement with the Vichy government in 1941–1942 to his work with ASCORAL (Association of Constructors for Architectural Renovation) from 1943 onward. It also filled a void: although books were still a very real part of the process of erecting buildings and developing towns–in order to promote them prior to construction, to document them after the fact (and before), and to publicize work in progress–they sometimes served as substitutes for implementing a program when circumstances made any form of implementation impossible.

The list of houses that agreed to publish Le Corbusier between 1940 and 1945 reflects the complexity and evolution of the architect's positions; it includes both Sorlot (*Destin de Paris*,[XXII] 1940) and Chiron (*Les Constructions Murondins*,[XXIII] 1942), who were based in Clermont-Ferrand and were protégés of (and sometimes subsidized by) the Vichy régime, as well as Gallimard (*Sur les quatre routes*,[XXIV] 1941), which was run by people who were part of the French Resistance. More ambiguous were the cases of Plon (*La Maison des hommes*,[XXV] 1942 and *La Charte d'Athènes*,[XXVI] 1943) and Denoël (*Entretien avec les étudiants des écoles d'architecture*,[XXVII] 1943) and *Les Trois Établissements humains*, 1945) to judge by their fate during the postwar purge.[13]

Le Corbusier's next two books were published in America and were never translated into French. *UN Headquarters*, published by Reinhold in 1947, is a collection of writings and sketches related to the future United Nations building in New York, while *New World of Space*, published by Reynal & Hitchcock in 1948, accompanied a Corbusier exhibition held that year in Boston prior to traveling across the United States and Europe. This volume also constituted a turning point in the content of Le Corbusier's books, henceforth characterized by a significant autobiographical dimension that stressed his combined output as architect and artist.

In the 1950s, the publishers whom Le Corbusier had long known began to work with him again. André Bloc, at Les Éditions de l'Architecture d'Aujourd'hui, thus backed *Le Modulor* (1950) and *Modulor 2*[XXVIII] (1955), which dealt with Le Corbusier's famous concept of "a harmonious measure to the human scale, universally applicable to architecture and mechanics." These books also dwelled on the author himself, on "his life and art." Hans Girsberger, who would finish publishing the "complete works" in 1971, brought out *Une petite maison* in 1954 (the first volume in a series called Carnets de la Recherche Patiente), which offered a detailed description of the villa

13 See Pascal Fouché, *L'Édition française sous l'Occupation* (Paris: Bibliothèque de Littérature Française Contemporaine, Université de Paris VII, 1987).

XXII The Fate of Paris
XXIII Round-Log Houses
XXIV *The Four Routes*, trans. Dorothy Todd (London: Dennis Dobson, 1947).
XXV The House of Mankind
XXVI *The Athens Charter*, trans. Anthony Eardley (New York: Grossman, 1973).
XXVII *Le Corbusier Talks with Students from the Schools of Architecture*, trans. Pierre Chase (New York: Orion Press, 1961).
XXVIII *The Modulor: A Harmonious Measure to the Human Scale Universally Applicable to Architecture and Mechanics*, trans. Peter de Francia and Anna Bostok (London: Faber and Faber, 1954); *Modulor I and II*, trans. Peter de Francia and Anna Bostok (Cambridge: Harvard University Press, 1980).

built by Le Corbusier for his parents in Corseaux. Meanwhile, Pierre Betz devoted a second issue of his magazine *Le Point* to Le Corbusier (1950), focusing on the Unité d'Habitation in Marseille even though construction of the Radiant City, to which the issue was dedicated, was not yet finished. Le Corbusier also wanted, however, to work with younger publishers such as Hermine Chastenet, who headed Les Éditions Falaize and published his *Poésie sur Alger* (1951), an elegant little illustrated booklet that transformed an urban-political issue into an artistic object. Then there was Gerd Hatje in Stuttgart, who published not only *Ronchamp*[XXIX] (1957, the second volume to appear under the imprint of Les Carnets de la Recherche Patiente), devoted to the recently built chapel of Notre-Dame du Haut in the Vosges region, but also Le Corbusier's final, ambitious biographical work, *Mein Werk*[XXX] (1960). Finally, there was Jérôme Lindon at Les Éditions de Minuit, who published the large album of *Plans de Paris* 1956–1922 (1956), plus three reissues edited by Jean Petit, who also hosted the Forces Vives imprint.

XXIX *The Chapel at Ronchamp*, trans. D. Cullen (New York: Praeger; London: Architectural Press, 1957).
XXX *Creation is a Patient Search*, trans. James Palmes (New York: Praeger, 1960).

CH-E. JEANNERET
ARCHITECTE

ÉTUDE
SUR LE MOUVEMENT
D'ART DÉCORATIF
EN ALLEMAGNE

1 9 1 2

commentaires
sur l'art et la vie moderne

I^{er} VOLUME PRIX DE CE VOLUME 4 fr. 50 5 fr.

OZENFANT ET JEANNERET

APRÈS LE CUBISME

DEUXIÈME ÉDITION

MDCCCCXVIII

PARIS
Édition des Commentaires
5, rue de Penthièvre, 5

The cover of *Vers une architecture*, 1923
240 × 150 mm

COLLECTION DE "L'ESPRIT NOUVEAU"

LE CORBUSIER

VERS UNE ARCHITECTURE

NOUVELLE ÉDITION REVUE ET AUGMENTÉE

LES ÉDITIONS G. CRÈS ET Cie
11, RUE DE SÈVRES (VIe)
PARIS

22e ÉDITION

COLLECTION DE " L'ESPRIT NOUVEAU "

LE CORBUSIER

L'ART DÉCORATIF D'AUJOURD'HUI

LES ÉDITIONS G. CRÈS ET Cie
24, RUE HAUTEFEUILLE, 24
PARIS

7e ÉDITION

COLLECTION DE " L'ESPRIT NOUVEAU "

OZENFANT & JEANNERET

LA PEINTURE MODERNE

LES ÉDITIONS G. CRÈS & Cie
21, RUE HAUTEFEUILLE, 21
PARIS

4e ÉDITION

COLLECTION DE " L'ESPRIT NOUVEAU "

LE CORBUSIER

URBANISME

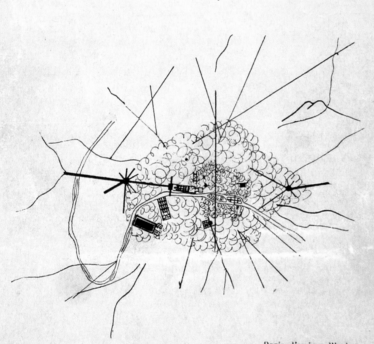

Paris d'aujourd'hui.

LES ÉDITIONS G. CRÈS & Cie
21, RUE HAUTEFEUILLE, 21
PARIS

2ᵉ ÉDITION

COLLECTION DE " L'ESPRIT NOUVEAU "

LE CORBUSIER

ALMANACH D'ARCHITECTURE MODERNE

LES ÉDITIONS G. CRÈS ET Cie
11, RUE DE SÈVRES (VIe)
PARIS

The cover of *Une Maison – un palais*, 1928
240 × 150 mm

COLLECTION DE "L'ESPRIT NOUVEAU"

LE CORBUSIER

UNE MAISON
- UN PALAIS

LES ÉDITIONS G. CRÈS ET Cie

11, RUE DE SÈVRES (VIe)

PARIS

The cover of *Précisions sur un état présent de l'architecture et de l'urbanisme*, 1930
240 × 150 mm

COLLECTION DE ''L'ESPRIT NOUVEAU''

LE CORBUSIER

PRÉCISIONS

SUR UN ÉTAT PRÉSENT
DE
L'ARCHITECTURE
ET DE
L'URBANISME

LES ÉDITIONS G. CRÈS ET Cie
11, RUE DE SÈVRES (VIe)
PARIS

The cover of *Croisade ou le crépuscule
des académies,* 1933
240 × 150 mm

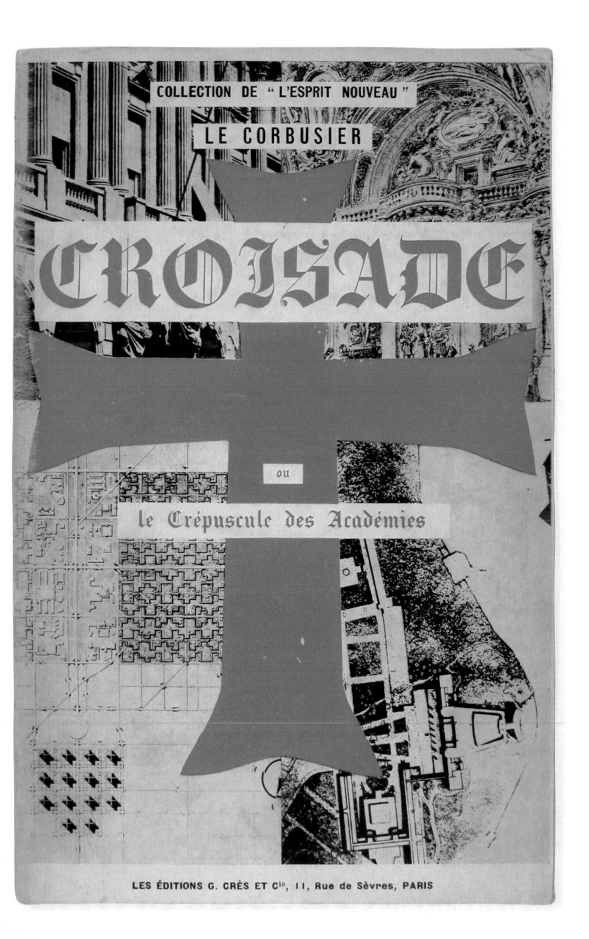

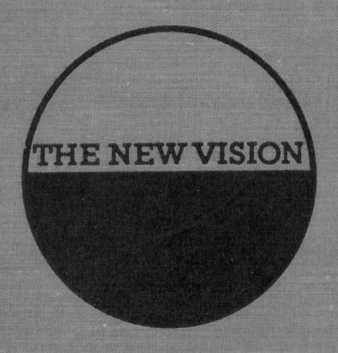

The cover of *La Ville radieuse*, 1935
230 × 300 mm

ÉQUIPEMENT DE LA CIVILISATION MACHINISTE

LE CORBUSIER

LE RADIEUSE

ÉDITIONS DE
L'ARCHITECTURE D'AUJOURD'HUI
5, RUE BARTHOLDI, 5

BOULOGNE (SEINE)

The cover of *Des canons, des munitions?*
Merci! Des logis… S.V.P., 1938
230 × 300 mm

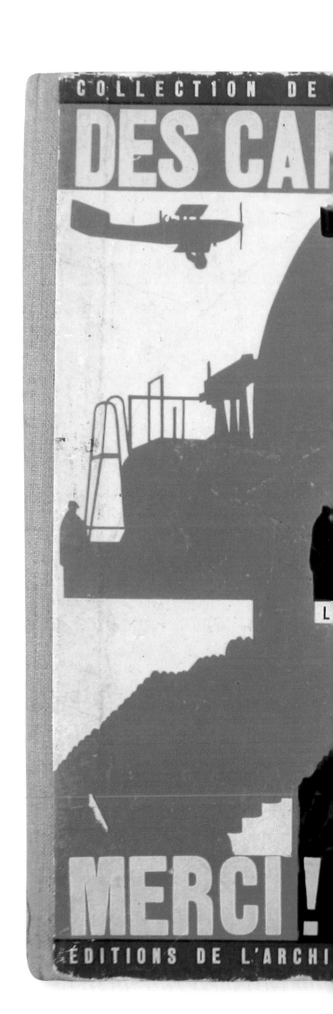

NS, DES MUNITIONS ?

BUSIER

DES LOGIS... S.V.P.

RE D'AUJOURD'HUI, 5, RUE BARTHOLDI, BOULOGNE (SEINE)

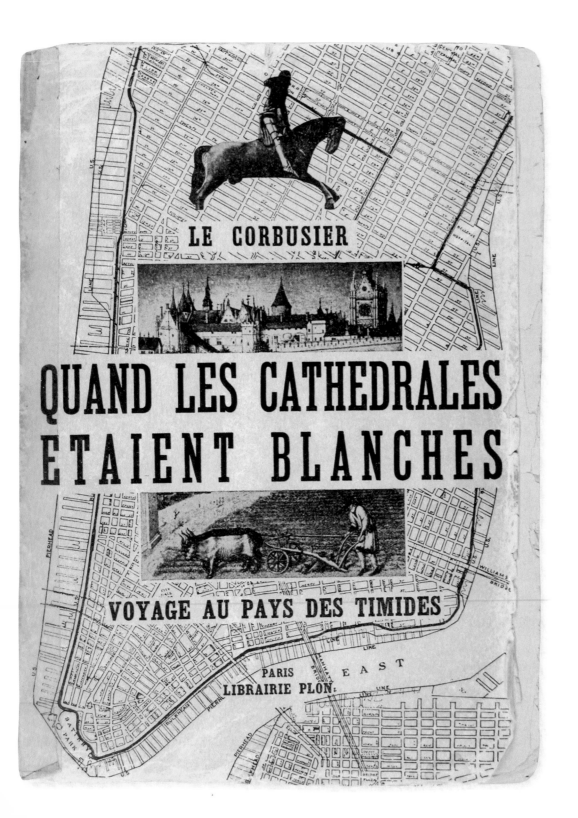

XX

LE POINT

LE POINT

LE LYRISME DES TEMPS NOUVEAUX
ET L'URBANISME

AVRIL 1939

FONDATION LE CORBUSIER

10, Square du Docteur-Blanche

PARIS 16e 288-41-53

The cover of *Destin de Paris,* 1941
180 × 118 mm

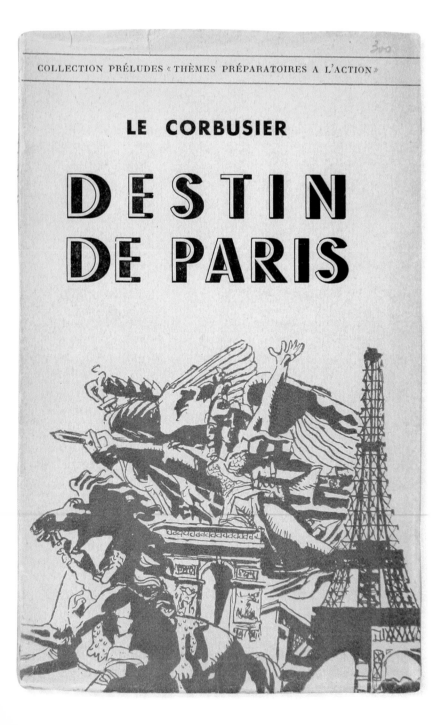

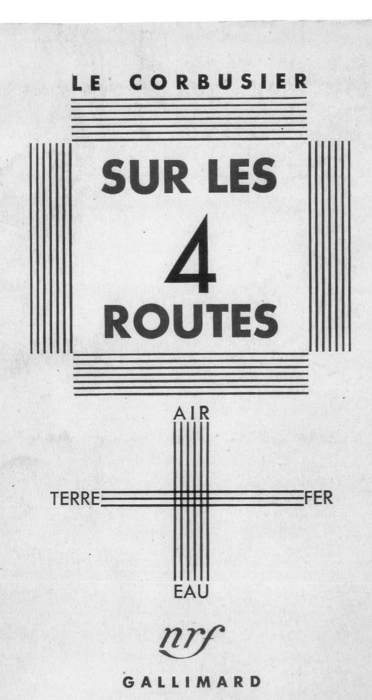

FRANÇOIS DE PIERREFEU
ET
LE CORBUSIER

LA MAISON
DES HOMMES

PARIS-LIBRAIRIE PLON

3ᵉ mille

The cover of *Les Constructions Murondins*, 1942
135 × 225 mm

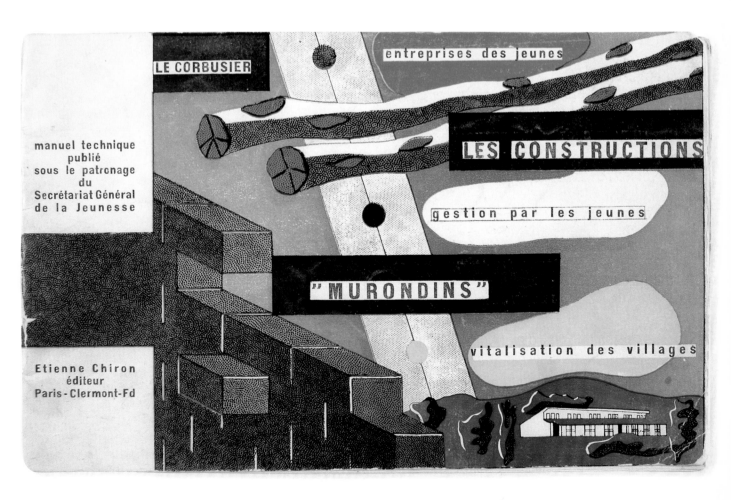

LE GROUPE CIAM-FRANCE

URBANISME DES C. I. A. M.

LA CHARTE D'ATHÈNES

avec

UN DISCOURS LIMINAIRE

de

JEAN GIRAUDOUX

PLON

The cover of *Entretien avec les étudiants
des écoles d'architecture,* 1943
160 × 120 mm

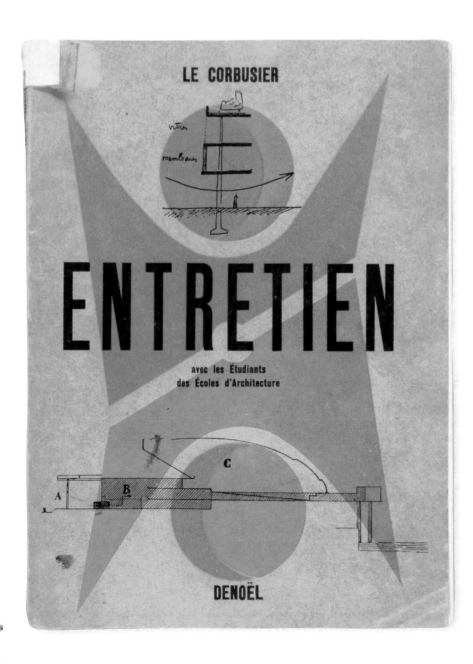

URBANISME DES CIAM

Collection **ASCORAL** dirigée par
LE CORBUSIER

Sections 5 a et 5 b

UNE CIVILISATION DU TRAVAIL

BÉZARD · J.COMMELIN · COUDOUIN · J.DAYRE · HY.A.DUBREUIL
LE CORBUSIER · LEYRITZ · HANNING · AUJAMES · DE LOOZE

LES
TROIS

7· VOLUME

ÉTABLISSEMENTS
HUMAINS

DENOËL

The cover of *Manière de penser l'urbanisme*
1946
223 × 155 mm

LE CORBUSIER

MANIÈRE DE PENSER L'URBANISME

URBANISME DES CIAM

ASCORAL

COLLECTION

DIRIGEE PAR
LE CORBUSIER

PREMIER VOLUME

EDITIONS DE L'ARCHITECTURE D'AUJOURD'HUI

Le Corbusier

UN
HEADQUARTERS

PRACTICAL APPLICATION
OF A PHILOSOPHY OF
THE DOMAIN OF BUILDING

The cover (dust jacket) of *New World of Space*
1948
280 × 220 mm

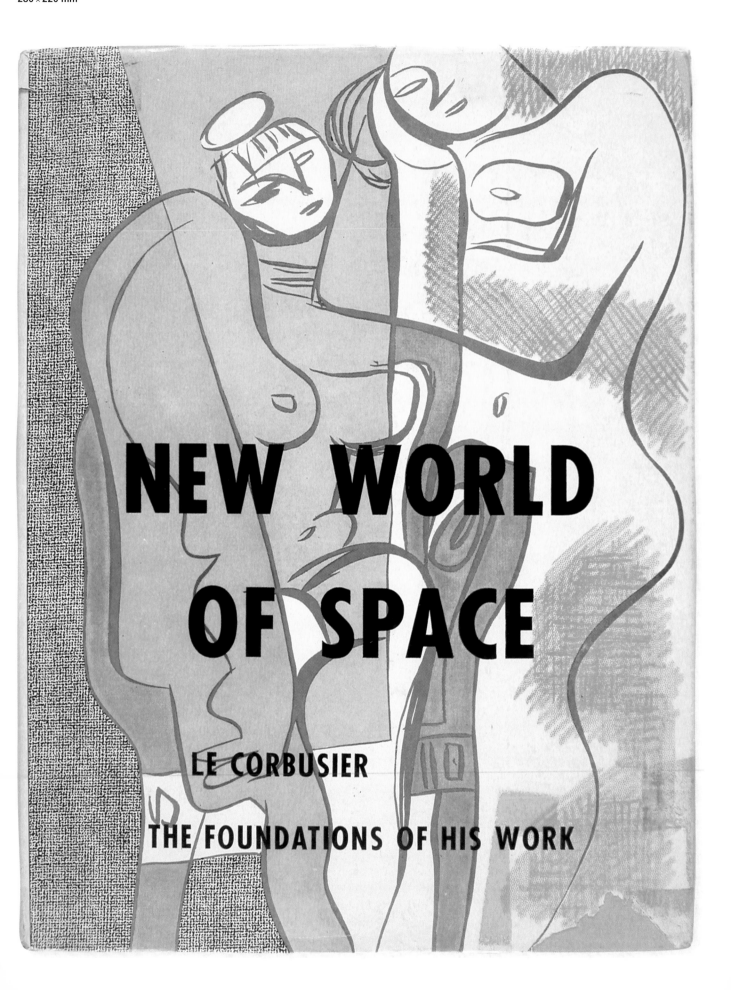

The cover of *Le Modulor,* 1950
145 × 145 mm

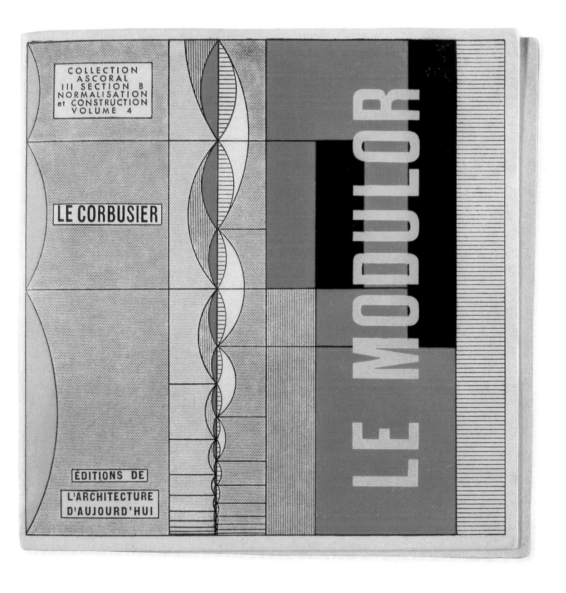

The cover (dust jacket) of "L'Unité d'habitation de Marseille", *Le Point*, n° XXXVIII, 1950
250 × 190 mm

LE CORBUSIER
L'UNITÉ
D'HABITATION
DE
MARSEILLE

LE POINT

•

SOUILLAC (Lot)
MULHOUSE
55, Rue Daguerre

The cover of *Poésie sur Alger,* 1951
170 × 110 mm

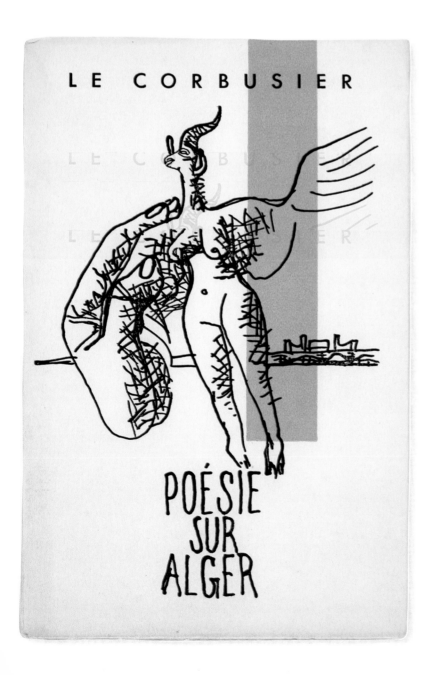

The cover of *Une petite maison*, 1954
165 × 120 mm

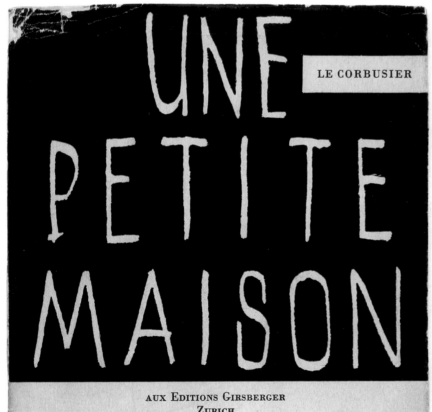

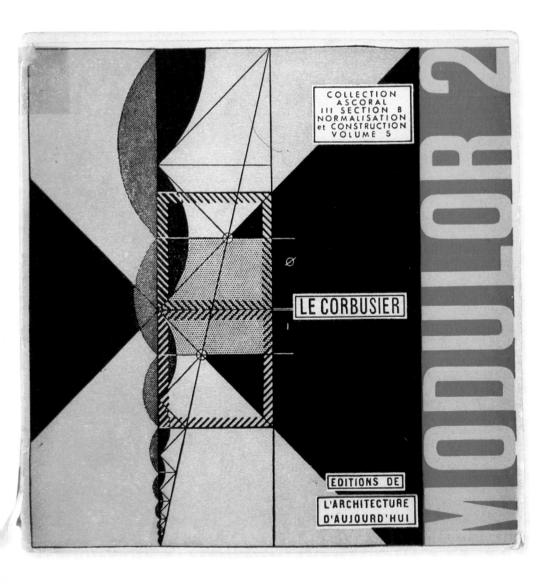

The cover of *Les Plans de Paris*, 1956
240 × 300 mm

S PLANS

ORBUSIER

DE

PARIS

56·1922

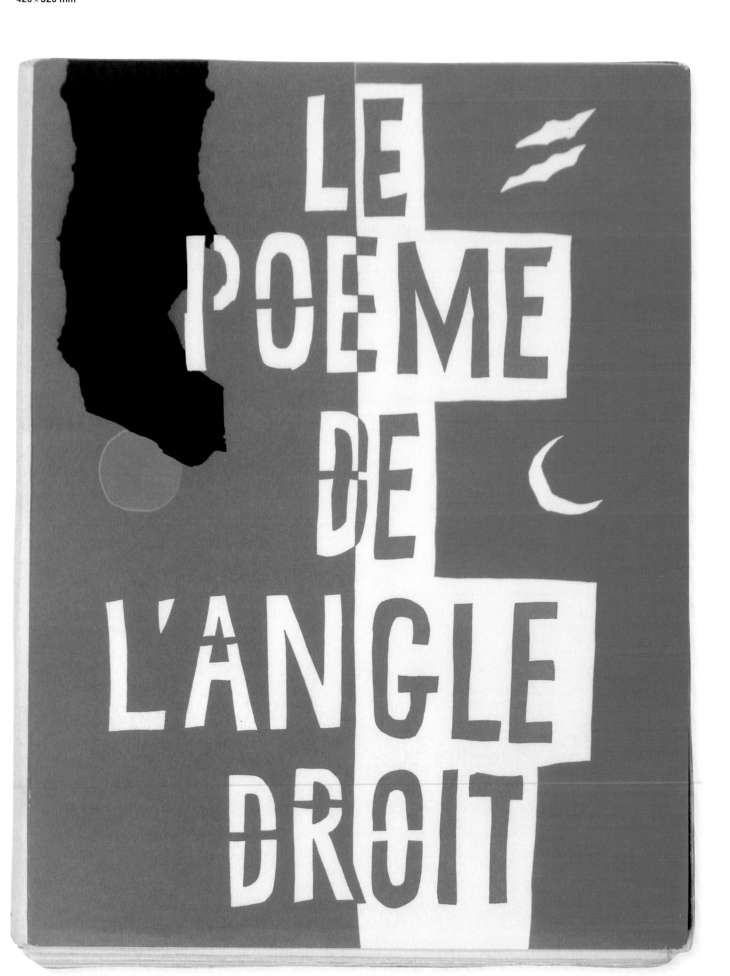

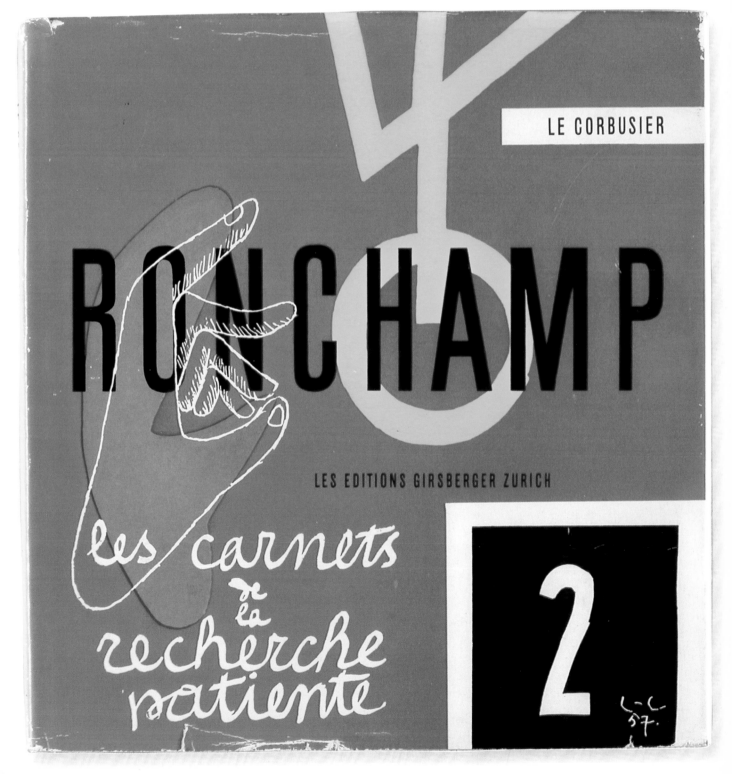

The cover (dust jacket) of *Mein Werk/L'Atelier*
de la recherche patiente, 1960
280 × 220 mm

AUTHOR AND PARTNERS—
UNDER TIGHT SUPERVISION

PUBLISHING HOUSES, LTD.

A book is never an entirely solitary venture. It is necessarily the fruit of a collective effort—not unlike architecture—which calls on a variety of skills. Le Corbusier was careful to determine personally the amount of responsibility delegated to each member of the publishing chain—editor, layout artist, printer—and to maintain control over the publishing process.

Le Corbusier's relationships with his publishers oscillated between open friendliness and outright hostility. The same individual would often be the target of both attitudes. These swings can be detected in Le Corbusier's correspondence, and would seem to mirror his relationships with his architectural clients.[14] Hence he could alternately flatter Girsberger in order to convince him to publish ("I felt you were at the heart of this international trend and could therefore handle this publication"[15]) and then become aggressive when things didn't go his way ("You managed to obtain subsidies from Swiss industrialists, but only to bail out your own business while LC always remains outside the money. Which is often tragic, yet which you don't want to admit. I was not in the least moved by the personal sentiments expressed in your letters."[16]).

Publishers, meanwhile, often had a hard time making the case for their own various obligations when faced with the demands of Le Corbusier, who throughout his life generally treated his publishers as service providers required to execute a task according to his own desires. He rarely granted them any critical role. An exception to this rule was his relationship with Gallimard; Jean Paulhan was allowed to express serious reservations on reading the first manuscript of *Sur les quatre routes in March* 1939 – "the tone is always interesting: enthusiastic, hurried. Some fine pages on Vézelay. But how jumbled, incoherent, haphazard, careless, and unbearable it all is."[17] Paulhan followed up with several salvos of corrections and suggested restructuring the manuscript. The text went through at least two different versions in 1940, followed by a last campaign of corrections in 1941.[18]

14 Jean Louis Cohen described a scenario of "seduction" followed by "shared bitterness" in "Le Corbusier: la tentation de l'universel," *Critique* 476-477 (January 1987), 52-53.
15 Letter from Le Corbusier to Hans Girsberger concerning *Le Modulor*, February 7, 1949 (FLC, F3-20-151).
16 Letter from Le Corbusier to Hans Girsberger, March 29, 1955 (FLC, G2-18-288).
17 FLC, E2-18-116 (March 1939).
18 See various pieces of correspondence in FLC B3-12 and FLC E2-18.

The cover and page from *La Charte d'Athènes,* 1943
145 × 135 mm

ALL-POWERFUL AUTHOR

Le Corbusier's writing—so castigated by Pierre Francastel for its "sports-fan style" and "basic lapses"[19]—would probably have benefited from careful correction more frequently, but the fact is that publishers rarely played that role with him. Nor did they dare dispute the architect's desiderata when it came to the physical appearance of his books.

For example, Plon's director Maurice Bourdel attempted to oppose the production of *La Charte d'Athènes* in the form of a "thick, square little block" as requested by Le Corbusier. Bourdel raised both technical objections ("it won't look like a block, due to lack of weight and thickness") and commercial drawbacks ("it runs the risk of harming sales … and will in no way resemble a book"). "If you are determined to have your way," added Bourdel, "we would prefer to bow out and let you attempt this venture with others."[20] But Plon didn't bow out, and ultimately published the book by acceding to all of Le Corbusier's wishes (with the exception of the cover). The architect fought hard to obtain the layout he desired—designed to compensate for the austerity of a text without illustrations—despite the publisher's objections of costliness (use of color, boldface, underlined sentences, and vignettes drawn from the printer's catalogue).

Generally, Le Corbusier's attitude betrayed a determination to carry out every task himself, including that of publisher. One good example was his keenness for launching imprints devoted almost exclusively to his own titles: L'Esprit Nouveau (published by Crès) in the 1920s, L'Équipement de la Civilisation Machiniste in the 1930s, ASCORAL in the 1940s, and Carnets de la Recherche Patiente in the 1950s (an imprint that provided a common label for books issued by different publishers). On occasion, Le Corbusier could even symbolically assume the publisher's identity, as he did on the cover of *Plans de Paris*, where he took the liberty of appropriating the corporate image of Les Éditions de Minuit by using the logo designed by Vercors[21]—a star attached to the firm's initial—in a kind of seal he created and incorporated into the overall composition of the page.

Le Corbusier's stubborn insistence on managing the stock of L'Esprit Nouveau books that survived the Crès bankruptcy, like his insistence on negotiating the republication of his titles himself, testify to his inclination to control every step in the publishing process. He did his own calculations to determine the cost of publication, and alone sought partners or arrangements for reducing the cost of a publication. He also liked to supervise

19 Pierre Francastel, *Art et technique aux XIXe et XXe siècles* (Paris: Minuit, 1956), 37-47.
20 Letter from Maurice Bourdel to Le Corbusier, April 6, 1942 (FLC, A2-17-123).
21 Vercors (a.k.a. Jean Bruller) was the cofounder of Les Éditions de Minuit in 1942; his famous wartime narrative, *Le Silence de la mer,* was the firm's first title.

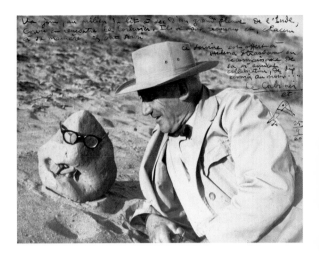

Photograph given by Le Corbusier to his literary agent, Helena Strassova, with a dedication that could be translated thus: "One day, in the middle of a large, dry riverbed in India, Crowby met Le Corbusier. On recognizing each other, each smiled in his own way. This smile is hereby awarded to Helena Strassova in gratitude for more than ten years of amicable, shared labor." 1960
Reproduced with the kind authorization of Éric Mouchet

The front and back covers of *Les Plans de Paris*, 1956
240 × 300 mm

personally the distribution of his books, stripping publishers of some of their prerogatives, notably by obliging them to forsake their usual press contacts (whom he felt were "sterile") in favor of dispatching complimentary copies to his own select list of important people.

THE UNCERTAIN ROLE OF LITERARY AGENT

Tight control over a process of this scope nevertheless entailed tricky tasks that Le Corbusier sought to delegate. The issue of artistic property was crucial to him in all realms of creative output. He became aware of the need to take measures to protect his interests when it came to his publishing activities. His search for a literary agent, interrupted when the war broke out and not taken up again until 1946, only bore fruit in the 1950s, when he finally entrusted his affairs to Helena Strassova, who would handle them for the rest of his life.

This relationship, however, did little to simplify things. Strassova complained that her responsibilities were poorly defined, and Le Corbusier in fact often went behind his agent's back, notably allowing Jean Petit to take the initiative on certain projects. These tactics were the source of numerous conflicts yet nevertheless enabled Le Corbusier to retain full and exclusive control over his affairs.

Strassova acted as a French agent for foreign authors—usually German—and a foreign agent for French authors.[22] Although she was born in Prague in 1900, her native language was German and she had been a professional singer in Berlin before fleeing Nazi Germany. She felt Le Corbusier was the most glamorous of the authors she represented, who included Konrad Lorenz, Marcel Pagnol, and René Char. Le Corbusier, meanwhile, displayed sincere friendship toward his agent, as witnessed by the dedication he inscribed to her on a photograph of himself taken in Chandigarh.[23] The dedication makes a clear if humorous allusion to editorial issues, because it incarnates the author's various signatures and his customary schizophrenia. The signature "Le Corbusier" accompanied by a drawing of a crow (*corbeau*) echoes the content of the photograph (the architect lying on the ground, outdoors, face turned toward a large rock that sports a pair of glasses) as well as the text, handwritten straight onto the photo in lieu of a caption: *la rencontre de "Corbu" et de "Le Corbusier"* ("Crowby meets Corbusier").

22 Most of the information on Helena Strassova comes from Monique Marie – Strassova's secretary from 1965 onward – based on my interview with her in May 2001.
23 Photograph dedicated by Le Corbusier to Helena Strassova on September 25, 1960. E. Mouchet Archives, Paris.

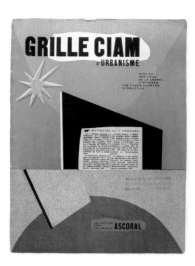

The cover of *Grille Ciam d'Urbanisme*, 1948
305 × 240 mm, 24 pages

YOUNGER PARTNERS "HOT OFF THE PRESS"

Once the war ended, printing techniques in France evolved and the range of graphic possibilities widened, thereby posing publishing issues in new terms for Le Corbusier. He thus began to listen to a younger generation of industry professionals in the expectation that they would help him to produce up-to-date books.

PIERRE FAUCHEUX: A NEW CONCEPTION OF GRAPHIC DESIGN

Pierre Faucheux (1924–1997) was a key figure in postwar French graphic design (as well as the designer of architectural projects). Over a period of several months in 1947 and 1948 he worked in Le Corbusier's studio on Rue de Sèvres, notably contributing to the graphic design of CIAM's town-planning grid (*Grille CIAM d'urbanisme*), as well as designing the membership cards for ASCORAL.

Trained in the French typographical tradition at the prestigious École Estienne in Paris, Faucheux stressed heavily Le Corbusier's influence on his work. In his memoirs, he recounted the impression made by reading *Vers une architecture* in 1944, which notably taught him the principle of regulating lines, a technique he applied to his own practice of page layout.[24] Following on from regulating lines, Faucheux adopted Le Corbusier's Modulor system and applied its measurements to his work both as a book designer and architect.

It is impossible to ignore the fact that Le Corbusier's interest in the creative art of page layout coincided with the period when Faucheux worked in his studio. He was sufficiently sure of the young man's talent to attempt to convince Alfred Roth and the Swiss CIAM team, who intended to publish a book on the twentieth jubilee of the Congress, 1928–1948, following the sixth convention held at Bridgewater in 1947, to abandon their project in favor of a French edition to be designed by Faucheux. "It is quite right that the Swiss group gather together all the documents. But when it comes to the final choice and the appearance of the book (typography, layout, etc.), I feel that Paris can handle it… At ASCORAL we have a young designer, Pierre Faucheux, who is right in the swing of things. He'll give CIAM that indispensable image of freedom and cheer."[25]

By suggesting that Faucheux could replace two heavy-weights of Swiss graphic design, namely Max Bill (who had already produced an initial dummy) and Richard-Paul Lohse (who would ultimately be responsible for

24 Pierre Faucheux, *Écrire l'espace* (Paris: Robert Laffont, 1978), and Marie-Christine Marquat (ed.), *Pierre Faucheux* (Paris: Cercle de la Librairie, 1995).
25 Letter from Le Corbusier to Alfred Roth, November 19, 1947 (FLC, D2-16-185). My thanks to Stanislaus von Moos for bringing this incident to my attention.

The cover (dust jacket) of *Le Corbusier
lui-même*, 1970
Text, layout, and publication by Jean Petit
275 × 275 mm

The cover (dust jacket) of *Kinder der
Strahlenden Stadt / Les Maternelles vous
parlent*, 1968
200 × 190 mm

26 Sigfried Giedion, *CIAM: A Decade of Contemporary Architecture* (Zurich: Girsberger, 1951).
27 "Le Corbusier: Architecture du bonheur/ L'urbanisme est une clef," *Les Cahiers Forces vives* 5-6-7 (1954).
28 Letter from Le Corbusier to Jean Petit, August 18, 1960 (FLC, E1-10-220).
29 Letter from Le Corbusier to Élisa Maillard, July 15, 1947 (FLC, G3-10-91).

XXXI *The Nursery Schools*, trans. Eleanor Levieux (New York: Orion Press, 1968).
XXXII *Concerning Town Planning*, trans. Clive Entwistle (London: Architectural Press, 1947).

the graphic design of the book),[26] Le Corbusier seems to have sensed the key role that this young graphic artist, "hot off the press," would play in the development of graphic design in the French publishing industry. And he made sure that his own books benefited from this fresh breeze that was sweeping the visual cobwebs from books published in France.

JEAN PETIT, PUBLISHING HEIR

As both graphic artist and publisher, Jean Petit was behind the 1952 founding of a periodical called *Les Cahiers Forces vives*, followed by an imprint of the same name. In 1954 he approached Le Corbusier, who gave him texts that resulted in a triple-issue of the review, illustrated by photographs by Lucien Hervé and a photographic portrait of Le Corbusier by Robert Doisneau.[27] This publication heralded a ten-year partnership, during which Petit would publish approximately ten titles by Le Corbusier (including three republications: *La Charte d'Athènes, Entretien, and Les Trois Établissements humains*). Following Le Corbusier's death–and up to his own demise in 1999–Petit retained the archives that provided some of the titles of the Cahiers Forces Vives imprint. Petit persisted with his editorial activities as the imprint moved from house to house (notably from Minuit to Éditec –Petit's own firm–then to Les Éditions Rousseau in Geneva and finally to Fidia Edizioni d'Arte in Lugano), without however completely exhausting the archival collection at his disposal.

The abundant correspondence between the two men shows how Petit's obvious enthusiasm and admiration appealed to Le Corbusier, who in return showed trust and esteem for the young, enterprising man for the rest of his life. Despite moments of anger and wariness on the part of the master ("You don't give a damn about an old codger of seventy-two... You're an exploiter of DEWs ['Dead by the End of the Week']," wrote the architect to Petit one day[28]), there is true affection: Le Corbusier adopted a friendly attitude toward the young man, blithely delegating work to him and involving him–almost as a second self–in issues of layout and typography, and in projects concerning other publishers, such as *Les maternelles vous parlent*[XXXI] (not published until 1968, by Hatje) and the new paperback editions published by Gonthier.

GERD HATJE: THE LAST PUBLISHER

Le Corbusier had been highly impressed by the quality of the German edition of *Propos d'urbanisme*,[XXXII] published by Gerd Hatje in 1954. That edition partially compensated for the "wretched" French version.[29] Le

Dummy pages for *L'Atelier de la recherche patiente* (pages not included in final book), 1960
Pencil, pen and various inks, collage on paper
228 × 222 mm

Le Corbusier with *Les Claviers de couleur Salubra,* circa 1960

Corbusier therefore entrusted two books to Hatje, *Ronchamp* and *Mein Werk*, both of which were also published in French with the new publisher given full responsibility. Thanks to his training as a typographer, which played a crucial role in the care he brought to his publications, Hatje – born in 1915 – founded his own publishing house in Stuttgart after the war, with architecture as one of his special fields.[30] Le Corbusier, although occasionally adopting an authoritarian or capricious attitude toward Hatje, appreciated the latter's professionalism (going so far, in a rare move, as to congratulate him for the relevance of his comments and corrections). In this vein, the correspondence reveals the publisher's skill at negotiating with his author, refusing to cave in to Le Corbusier's demands despite feeling intimidated, as he himself confessed, at the start of their relationship. In his last book, dated 1960, Le Corbusier wanted to allocate most of the space to his artistic activities, but Hatje, determined to give the book every chance of success, opposed this plan – and won.

A large part of Hatje's catalogue was devoted to titles on art, notably a series of monographs on contemporary artists. On receiving Hatje's volume on Picasso in 1963, Le Corbusier inevitably expressed the hope that his German publisher would produce a book on his own graphic works – to which he received a reply that something might be possible in a new series devoted to "those artistic œuvres whose success is not yet secure."[31] Straight talk from a true publisher.

30 The Hatje firm would merge with Cantz in the late 1990s.
31 Letter from Le Corbusier to Hatje, January 27, 1963; reply dated February 27, 1963 (FLC, U3-1-197 and 198).

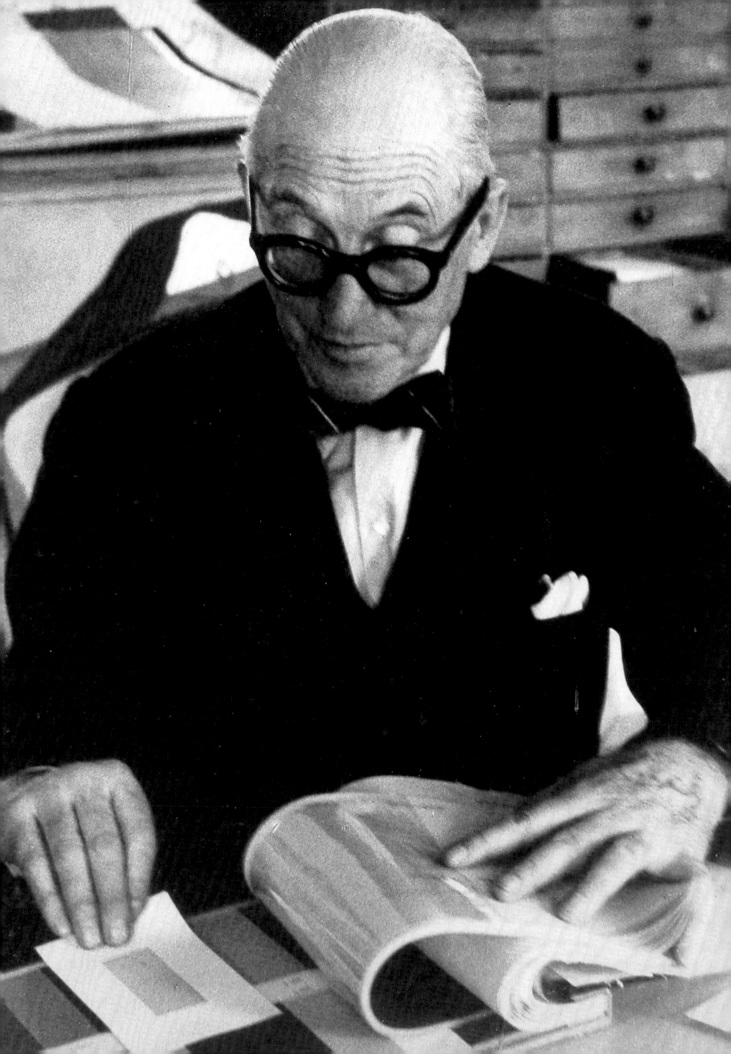

MAKING
A BOOK

The cover of *L'Esprit nouveau,* 1920–1925
250 × 150 mm

LAYOUT AND TYPOGRAPHY, FROM DIDOT TO DADA

A UNIQUE – IF CONVENTIONAL – IMAGE

"Remember the singular appearance, chaotic at first sight yet so shrewdly organized; remember those original illustrations, based on surprising – some beautiful, some comic – photographs of aerial views as well as pictures of gears and motors, old-fashioned crockery, 'period' furniture, pipes, telephone receivers, or those based on ink sketches, sometimes charming and meticulous, other times swift and lively, but always attempting to drive a rigorous argument into the reader's mind with whatever nail is at hand. He would shake and tickle the reader, known to be apathetic and dim. Or take sly digs at the reader, and also appall and infuriate him."[32] Élie Faure's 1935 description of the visual content of books published by Le Corbusier since the early 1920s is a fair representation of the uniqueness of his editorial œuvre – a "singular appearance" essentially produced by the great diversity of illustration. In contrast, the overall layout of these books remained loyal to conventions that other people elsewhere in Europe were attempting to shatter.

On this score, the Esprit Nouveau imprint reflected the approach of the review of the same name, whose visual image differed from many contemporary periodicals that adopted a similar cultural position (and with whom there was nevertheless a frequent exchange of texts and ideas), such as *Ma* (Hungary), *Disk* (Czechoslovakia), *Lef* (Russia), *G* (Germany), and *De Stijl* (Holland), to name just a few.

DADA SPIRIT AND ROMANTIC TRADITION

The real connection with contemporary artistic developments therefore lay elsewhere. For example, certain affinities with the Dada movement can be glimpsed in Le Corbusier's adoption, throughout a book or periodical, of an approach to visual montage inspired less by conventional publications than by vernacular forms of page layout, such as those found in advertising leaflets and other pamphlets.[33] Similarly, he often took an ironic, distanced approach to typography and illustration. Thus the titles in *L'Almanach d'architecture moderne* were composed in different typefaces adapted

32 Élie Faure, "La Ville radieuse," *L'Architecture d'aujourd'hui* 11 (1935), 1–2.
33 On this subject see Beatriz Colomina, *Privacy and Publicity: Modern Architecture and the Mass Media* (Cambridge, Mass./London: The MIT Press, 1994).

Photo Giraudon

DES POTS.

« Dans la période actuelle, où la céramique d'art est devenue un envahissement calami-
teux on peut se demander quelle destinée peut être fixée à la poterie, *aux vases*.
Si l'on se place à un point de vue sévère, au point de vue du grand art, on pourra réserver

DES POTS...

DES TAPIS DÉCORATIFS

Ceux du Pavillon de l'*Esprit Nouveau* étaient *berbères, nègres.*

Proposal for the cover of *Vers une architecture*
1922–1923
Pen and ink on paper
250 × 160 mm

Mock-up of the cover for *Vers une architecture*
1922–1923
Pencil, pen and ink, and collage on paper
250 × 155 mm

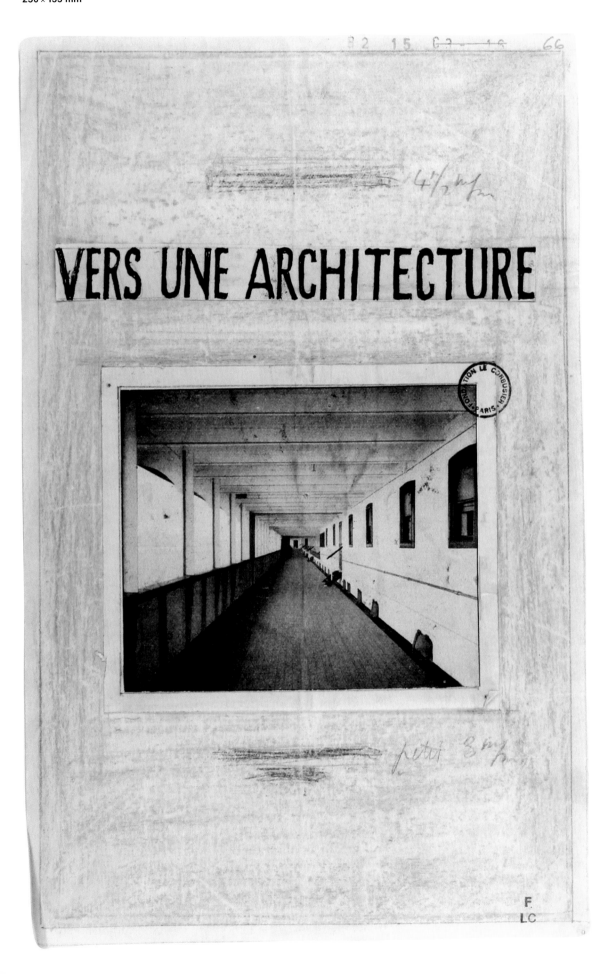

Double-page spread from *Urbanisme*, 1925
240 × 150 mm

Page from *L'Art décoratif
d'aujourd'hui*, 1925
240 × 150 mm

Page from *Urbanisme*, 1925
240 × 150 mm

to the editorial content, which prompted Le Corbusier to reassure the printer: "funny lettering, please, it's for fun."[34] And a blank page in *Urbanisme* was framed by a thin rectangular border for an image that was missing, replaced by a brief phrase (a joke, or perhaps proto-conceptual art): "left blank for a work expressing modern feeling."[35]

It would also appear that Le Corbusier was relatively open to the idea of ready-mades, as illustrated by the bidet featured in the article on "Other Icons – Museums," published in both *L'Esprit nouveau and L'Art décoratif d'aujourd'hui* and clearly alluding to Marcel Duchamp's notorious urinal, dubbed *Fountain*.[36] The visual design of the books published during the Crès period was modern in certain respects and might also be linked to certain contemporary art practices in so far as it notably involved sampling imagery from Le Corbusier's daily environment – news clippings, advertisements, excerpts from sales catalogues, etc. It thereby reflected the artistic explorations of the day. Yet these layouts might also be viewed from the standpoint of the Romantic publishing tradition of books and "picturesque" magazines that juxtaposed heterogeneous images and reveled in a pell-mell effect, making a metaphorical allusion to the architectural space of a "bazaar."

This analogy would align Le Corbusier with a nineteenth-century heritage, underscoring the distance that separated him from the international avant-gardes of the 1920s, concerned as they were to transform (among other things) the rules of the visual game governing the printed page. For example, a comparison of Le Corbusier's books with Moholy-Nagy's Bauhausbücher or Bruno Taut's volumes (designed by Johannes Molzahn) – all very spare, geometrical, and asymmetrical in visual conception – reveals the fundamental visual gap separating the former from the latter. When the young Jeanneret opted to move permanently to France in 1918, he also adopted the graphic traditions of his new country, as well as the somewhat old-fashioned attitudes of his new publishing environment.

34 Manuscript pages from *Almanach* (FLC, B1-19-12).
35 Le Corbusier, *The City of Tomorrow and Its Planning*, trans. Frederick Etchells (New York: Payson & Clarke, 1929), 38.
36 See Stanislaus von Moos, "Le Corbusier et Loos," in Stanislaus von Moos (ed.), *L'Esprit nouveau: Le Corbusier et l'industrie*, (Zurich/Berlin: Museum für Gestaltung-Ernst und Sohn, 1987), 125; see also Colomina, *Privacy and Publicity*, 139–148.

Double-page spread from _Vers une architecture_, 1923
240 × 150 mm

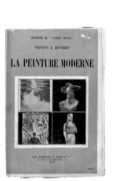

Double-page spread from _La Peinture moderne_, 1925
240 × 150 mm

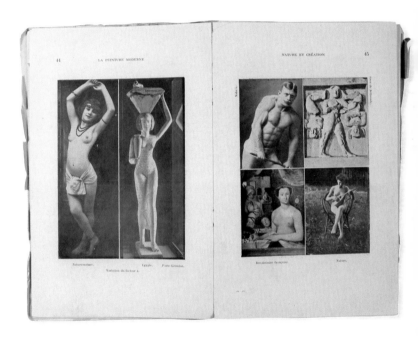

Double-page spread from _L'Art décoratif d'aujourd'hui_, 1925
240 × 150 mm

Pages from the dummy of *Croisade*, 1932–1933
Ink, pencil and collage on paper
250 × 165 mm

F.
LC

la
Appuyé au bastingage de cette galère, Le Corbusier pensait :
« Il faut chercher la lumière. Un phare est-il capable d'éclairer
les routes tempétueuses de cette architecture nouvelle qui naît
d'un siècle nouveau ? »
Dans sa mémoire surgissait alors cette planche N° 2
de l'album qu'un maître avait dédié aux jeunes
élèves venus acquérir la science sévère.

8¾

F.
LC

Une autre planche 9: l'Album leur apparant parallèlement o- &
image concomitant...

« Eupalinos, songeait-il, recherchait la raison des choses »
Il était fort frappé des analogies qui, dans cette présente époque,
lient l'âme à par l'autre, toutes les œuvres entreprises pour obtenir l'efficacité
des gestes et attentive à la glorification de l'esprit
Et il était persuadé que l'architecture a ce don
miraculeux de mettre toutes les choses en harmonie.

(il avait en la sensation que)

Toujours appuyé au bastingage de la galerie, le Corbusier se souvint
qu'un soir, après qu'il avait harangué une foule de gens venus
pour s'informer, quelqu'un s'était levé. Et, ayant évoqué les leçons
de l'histoire, il avait désigné du doigt et
s'était écrié : « Cet homme ment-il ?
(cet homme qui prêche à son tour une croisade ?) »

Proposal for the cover of *Des Canons, des munitions ? Merci ! Des logis… S.V.P.*, 1937–1938
Pencil on paper
230 × 305 mm

Proposal for the cover of *Des Canons, des munitions ? Merci ! Des logis… S.V.P.*, 1937–1938
Pencil, pen and ink on paper
235 × 290 mm

Cover of the dummy of *Des Canons, des munitions ? Merci ! Des logis… S.V.P.*, 1937–1938
Gouache on paper
230 × 300 mm

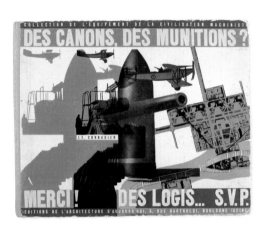

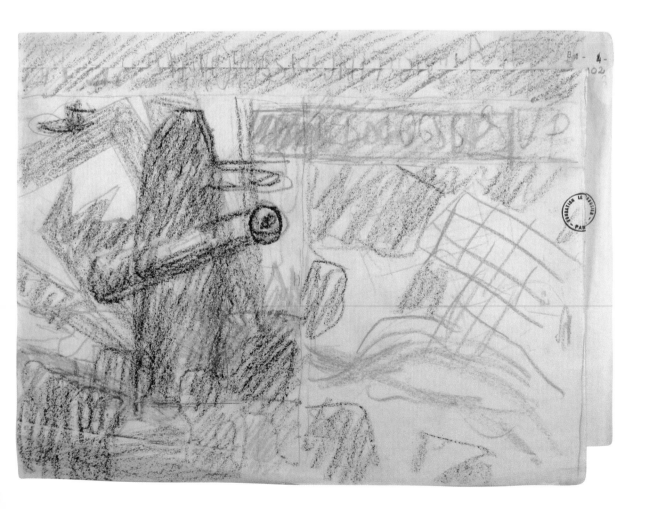

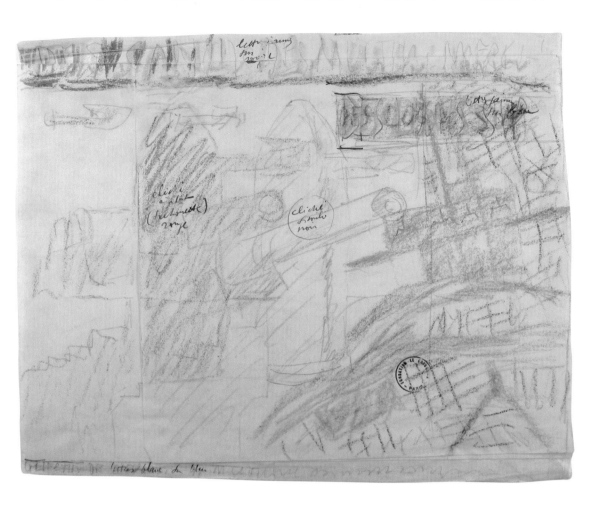

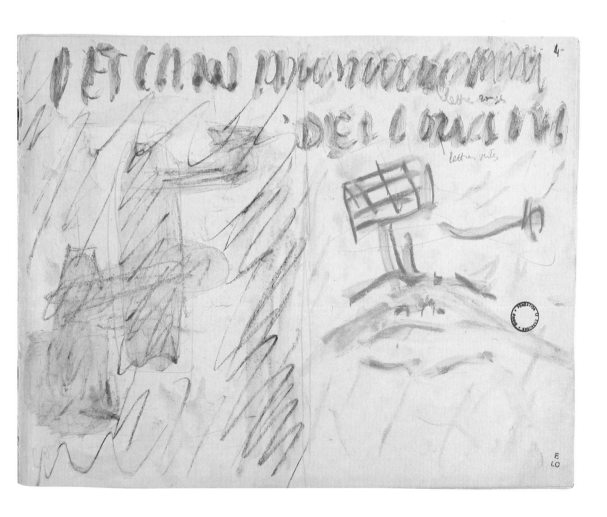

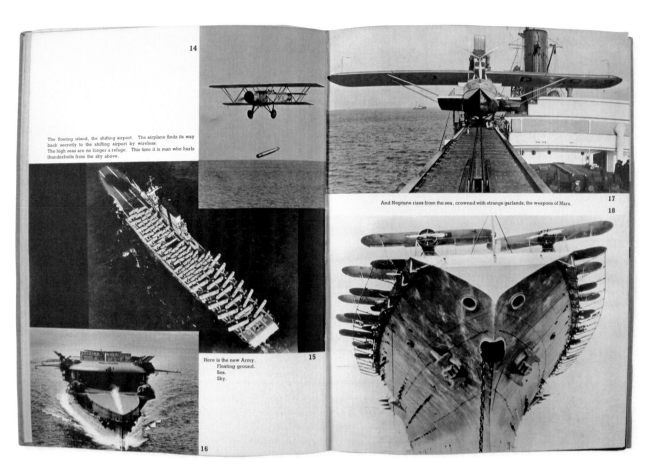

14

The floating island, the shifting airport. The airplane finds its way back secretly to the shifting airport by wireless.
The high seas are no longer a refuge. This time it is man who hurls thunderbolts from the sky above.

And Neptune rises from the sea, crowned with strange garlands, the weapons of Mars. 17

18

Here is the new Army.
Floating ground.
Sea.
Sky. 15

16

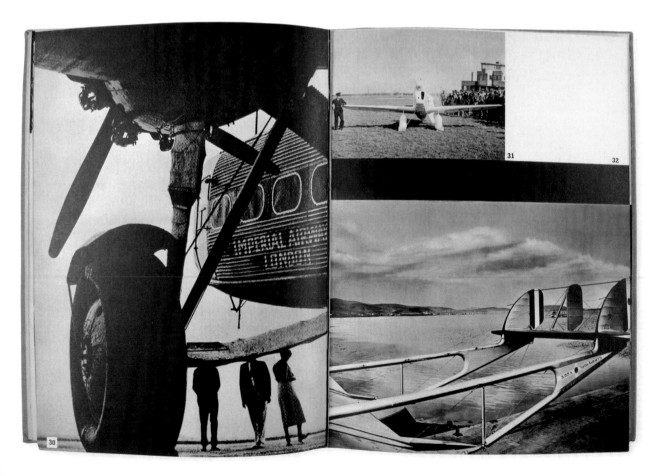

31

32

30

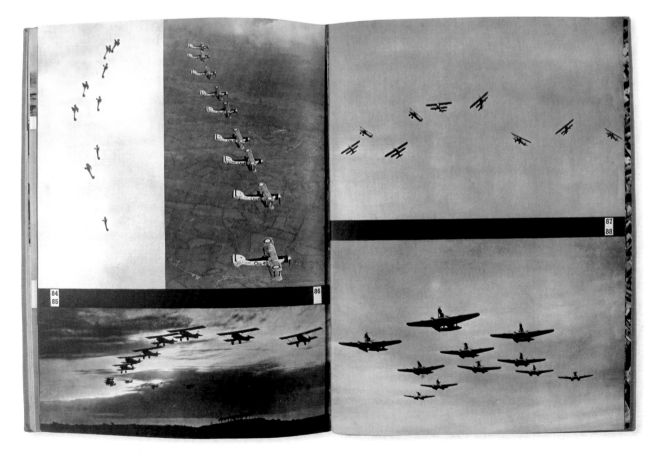

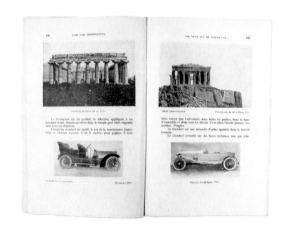

Page from *Précisions sur un état présent de l'architecture et de l'urbanisme*, 1930
240 × 150 mm

Double-page spread from *Vers une architecture*, 1923
240 × 150 mm

THE PARALLEL MESSAGE OF PICTURES

Yet the illustrations employed in the Esprit Nouveau series displayed both originality and efficiency. Organized in such a way as to provide a "parallel message," as described in the advertising copy for *Vers une architecture*, the imagery was supposed to "dazzle the reader's eyes" and lend a new "expressiveness" to the book. Le Corbusier thus juxtaposed apparently unrelated items on the same page or facing pages: automobiles versus ancient temples (*Vers une architecture*), the church of Hagia Sophia in Constantinople versus a child's drawing (*L'Art décoratif*), a plan of Paris versus the wall of China (*Urbanisme*).[37] Perceived as "impertinent jokes" or "inspired anthologies" depending on the reader's attitude,[38] these unexpected juxtapositions generally aimed to reveal not the distinctions but the connections between the images – the stronger the contrast, the more powerful the revelation.

The imagery haphazardly mingled drawings with photographs, the latter occasionally featuring close-up shots or unexpected compositions. In counterpoint to the text, *Précisions sur un état présent de l'architecture et de l'urbanisme*[XXXIII] (1930) presented drawings sketched by Le Corbusier during his lectures in South America, thereby playing on the improvisational effect of this multitude of coarsely-drawn sketches with their striking handwritten comments. In *L'Art décoratif*, the outlines of certain silhouetted objects stand out on the page. These few effects nevertheless remained modest compared to the transformations of imagery being carried out by many artists and photographers of the day, and it was only with the eighth and last volume of the series, *Croisade ou le crépuscule des académies*,[XXXIV] that Le Corbusier used photomontage for the first time.

MODERNIST INFLUENCES

The publication of *Croisade* coincided with the recent spread in France of magazines that devoted most of their space to photographs, beginning with *Vu* magazine, founded in 1928 by Lucien Vogel. The covers of *Vu* in the 1930s (largely the work of Alexander Libermann) were primarily produced through photomontage. Then came *Voilà* in 1931, followed by *Regards* in 1932. Now, Le Corbusier had begun contributing to *Vu* in 1931, and the magazine was one of the sources he used to compile his own stock of images. Concerning this matter, he pointed out in *Croisade* that "most of the pictures accompanying the architecture are taken from the weekly magazines *Vu* and *Voilà*."[39] Furthermore, his use of the photomontage tech-

37 *Vers une architecture*, 106-107; *L'Art décoratif*, 150-151; *Urbanisme*, 168-169.
38 Expressions quoted by Maximilien Gauthier, who attributed them to Jacques-Émile Blanche, *Le Corbusier: L'architecture au service de l'homme* (Paris: Denoël, 1944), 72-73.
39 Le Corbusier, *Croisade ou la crépuscule des académies* (Paris: G. Crès & Cie., 1933), 72.

XXXIII *Precisions on the Present State of Architecture and City Planning*, trans. Edith Schreiber Aujame (Cambridge, Mass.: MIT Press, 1991).
XXXIV Crusade, or, The Twilight of the Academies

nique, which had been historically linked to political struggle (from John Heartfield in Germany to the constructivists in the USSR), was intended to heighten the polemical impact of this booklet (which was a response to a lecture given by Gustave Umbdenstock, an architect who enjoyed multiple official posts and who defended traditional building techniques in the names of "Art" and "France"). The jeering tone of Le Corbusier's text is echoed in the illustrations through the montage of pictures – the superimposition and interpenetration of images underscores the contrast between two aesthetic approaches, demonstrating the superiority of modern forms over outmoded embellishments. Le Corbusier would employ photomontage once more on the cover of *Des canons, des munitions? Merci! Des Logis... SVP.*, whose propagandistic subject – antiwar, pro-housing – again justified recourse to this technique. With its efficient message and lively, appealing colors (black, blue, red, yellow, and green), this cover recalls Libermann's compositions for *Vu* even more directly than the cover of *Croisade*.[40] *Des canons* nevertheless holds a certain disappointment for readers hoping that the interior layout might match the quality of the cover.

It was with *Aircraft* that Le Corbusier produced the most "modernist" layout of his career. The images – exclusively black-and-white – are extremely varied in size and present multiple viewing angles. Each page is different. Some photographs are printed side by side while others overlap; sometimes a single image occupies the entire surface, bleeding off the edge, while in other cases five different views are juxtaposed. The blank areas between the reproductions are sometimes filled with a flat black zone and sometimes left empty. The text blocks constantly change throughout the book. *Aircraft* was supposed to inaugurate the publisher's New Vision series, each volume of which would be "devoted to one characteristic section of design in industry."[41] The visual design of this book – the one by Le Corbusier most influenced by the Bauhaus – bears some relation to Moï Ver's wonderful *Paris*, a book of photographs with an introduction by Fernand Léger, published in 1931 by Jeanne Walter (who also copublished, with Philippe Lamour, the magazine *Plans*, to which Le Corbusier was a regular contributor).[42]

TYPOGRAPHY: DIDOT AND ANTIQUES

Le Corbusier usually adopted a classic approach to typography, clinging to his preference for Didot typefaces – as stipulated on most of his dummies – right to the end of his life. When it came to foreign editions, he leaned

40 *Des Canons...* is devoted both to the construction of the Pavillon des Temps Nouveaux at the 1937 World's Fair and to the exhibition it housed. The murals conceived for the occasion (by Sert, Perriand, Le Corbusier, and others) were themselves largely "photomontaged."
41 Letter from Gaunt, head of The Studio, Ltd., to Le Corbusier, January 1935 (FLC, B3-14-1).
42 Moï Ver, *Paris* (Paris: Éditions Jeanne Walter, 1931). Ver, whose real name was Moshe Raviv-Vorobeichic, was a Lithuanian who studied at the Bauhaus before moving to France.

43 Working notes (labeled EN I / II), reproduced by Gladys Fabre, "De l'iconographie moderniste au modernisme de conception," in Gladys Fabre (ed.), *Léger et l'esprit moderne* (Paris: Musée d'Art Moderne de la Ville de Paris, 1982), 115. Fabre does not provide a reference for the note, and the caption to the reproduction of the handwritten text suggests a different transcription than the one proposed here.
44 On this subject, see the proceedings of the 2001 symposium held at the German Art History Center, edited by Isabelle Ewig, Thomas W. Gaehtgens, and Matthias Noell, *Das Bauhaus und Frankreich, Le Bauhaus et la France*, 1919–1940 (Berlin: Akademie Verlag, 2002), notably the article by Roxane Jubert, "Typographie et graphisme, dissemblances, dissonances… Disconvenance? La France en marge de la révolution typographique," 163-188.
45 Robin Kinross, *Modern Typography: An Essay in Critical History* (London: Hyphen Press, 1992), 80.
46 Letter from Le Corbusier to Jean-Louis Ferrier, July 10, 1963 (FLC, E2-2-135). The classification "antique" (which is feminine in French) refers to group of sans serif letterforms also known as "lineal" ("linéal" or "bâton" in French). Le Corbusier's technical description is therefore erroneously redundant; it would have been more correct to write "antiques allongées," a group of typefaces found in the Deberny & Peignot catalogues of the day.
47 Ibid.
48 Letraset catalogue, 1988, 1.56. According to the Fondation Le Corbusier, Letraset improperly credited Le Corbusier with paternity of this typeface, designed by Thevenon in 1873 (letter from Evelyne Trehin to Jack Leever, September 30, 1996).

toward Bodoni. A note on a typeface designed by Josef Albers reveals that he was fully cognizant of his own position on what he thought were whimsical typographical experiments. "Albers' letterforms [are] idiotic," he commented, adding for himself: "Make a note with a page of typefaces we'll adopt – legible. And dismiss: 1. Albers / 2. Giedion Bauhaus elimination of upper case."[43]

Le Corbusier's attitude reflects the one adopted by the French in general, for they displayed great reserve – indeed, open hostility – toward the typographical research done at the Bauhaus and by avant-garde lettering movements.[44] Robin Kinross could even refer to France as a truly surprising case of "marginality in twentieth-century typography," describing a situation in which trade publishers based their standards on Enlightenment printing traditions, thereby remaining impervious to any reformist or renovating trends in typesetting.[45] Only this French backwardness can explain how Le Corbusier could remind one of his publishers in the 1960s that he was the putative designer of "a Le Corbusier typeface based on oblong antique lineal letterforms ('caractères antiques bâton allongé' [*sic*])."[46] He was thus associating the antique, or lineal, group of typefaces, which had indeed been used in more than half his books published since the 1920s, with a "modern" image – his own. "Your paperbacks could very well present 'Le Corbusier' as being modern (typography) while 'Plato' would remain classic," he urged the reticent publisher.[47] Although the modernity of the typeface in question now appears highly relative (because it rested solely on the absence of serifs), the reticence displayed by the publisher, keen to use a serifed typeface for the titles of all his covers and little inclined to bow to the author's wishes, reveals the yardstick against which Le Corbusier's typographical choices should be measured.

STENCILS

Le Corbusier felt that antique letterforms represented "his" typography, yet it was another typeface that history would associate with his memory. Up until 1988 the catalogues of the Letraset company offered a stenciled typeface named Charette, attributed to Le Corbusier. This typeface, used for the logo of the Fondation Le Corbusier, also found on the covers of several books about the architect after his death, was used by Le Corbusier and his studio for the titles and captions of agency documents. The shape of the letterforms, traced with a stencil, corresponded to an alphabet probably designed in the nineteenth century.[48] The title pages of *Modulor 2*

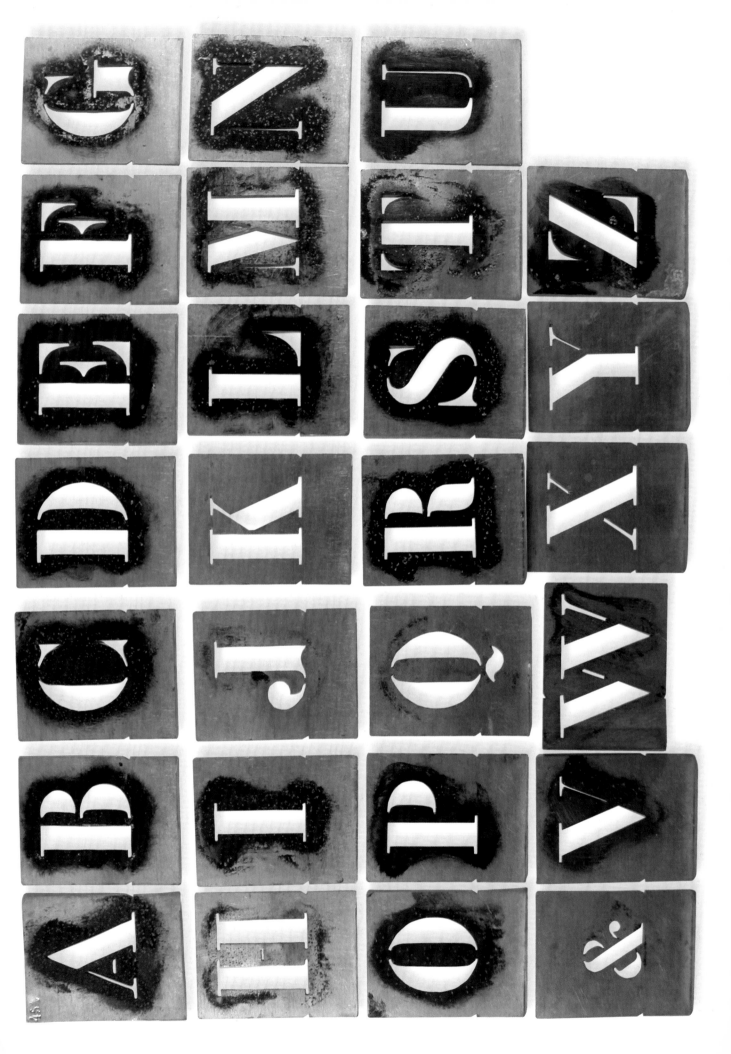

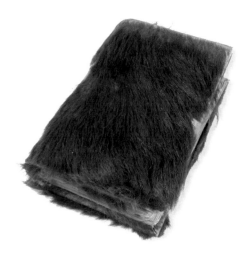

constitute the sole occasion on which it was used by Le Corbusier for book publication (excepting reproductions of existing plates).[49]

This was just one model, among others, of stenciled lettering commonly used in a variety of fields. And Le Corbusier just happened to be the most famous user of this typeface. Once the Letraset company was bought out and then folded, the Charette typeface completely disappeared from circulation. It is interesting to note that the stencil lettering chosen for the title of *Les Plans de Paris* was not Charette, but was a typeface designed by Marcel Jacno.[50] Known as Chaillot, this typeface was later used by Jean Petit for the books he published with Le Corbusier.

Subsequently, use of this lettering has remained associated with Le Corbusier's image—to this day, the metallic stencil frames sold to architects in the United States are known as "Corbu Stencils."

ANTI-BIBLIOPHILE

Although Le Corbusier paid close attention to issues of illustration, layout, and typography, his interest in the visual and physical appearance of his books diverged from the traditional considerations of a bibliophile. True enough, he did produce at least one book that fit into the category of a collector's item, *Le Poème de l'angle droit*. But above all this portfolio-style publication fulfilled Le Corbusier's desire to stake out artistic claims, for it was part of a series that had already included Matisse, Picasso, and Léger.[51]

The French bourgeois tradition of taking a new book to a binder and having it bound in fine leather was still thriving in the mid-twentieth century, but it remained quite alien to Le Corbusier, who rarely had it done. He did bind one of his favorite books, *Don Quixote*, allegedly in leather made from the hide of one of his dogs, "Pinceau," but the macabre bizarreness of such an act goes beyond the conventional fetishism of lovers of fine books. Although the cover is now heavily worn from the effects of time and frequent handling, the contrast between the brown, very animal-like outer surface and the inner lining of bright, red-and-yellow striped fabric is very striking, making this book a most unusual object and providing evidence of a certain eccentricity on the part of Le Corbusier.[52] The vast majority of the books in his personal library, however, remained in their original cloth bindings.

49 The Fondation Le Corbusier holds some ten project proposals in the form of booklets, most of which were laid out according the CIAM grid established by Le Corbusier and Pierre Faucheux, and which used Charette fonts (see, for example, "Le Musée du XXe siècle," reproduced in Le Corbusier, *Œuvre complète 7*: 164-165). Pierre Faucheux notably used this typeface for a catalogue accompanying the 1966 Corbusier exhibition at the Union Centrale des Arts Décoratifs in Paris.
50 Jacno designed the typeface in 1951 for the poster of the Théâtre National Populaire; it was incorporated into the Deberny & Peignot catalogue in 1956 under the name Chaillot.
51 Henri Matisse, *Jazz* (Paris: Tériade, 1947); Pierre Reverdy, *Le Chant des morts*, illustrated by Pablo Picasso (Paris: Tériade, 1948); Fernand Léger, *Cirque* (Paris: Tériade, 1950).
52 The volume in question is Miguel de Cervantès Saavedra, *L'Admirable Don Quichotte de la Mancha*, vol. 2, translated into French by Damas-Hinard (Paris: Charpentier, 1847). The book is now held by the Fondation Le Corbusier. Several accounts indicated that Le Corbusier was in the habit of preserving the hides of his deceased dogs, and sometimes even hung them on the wall.

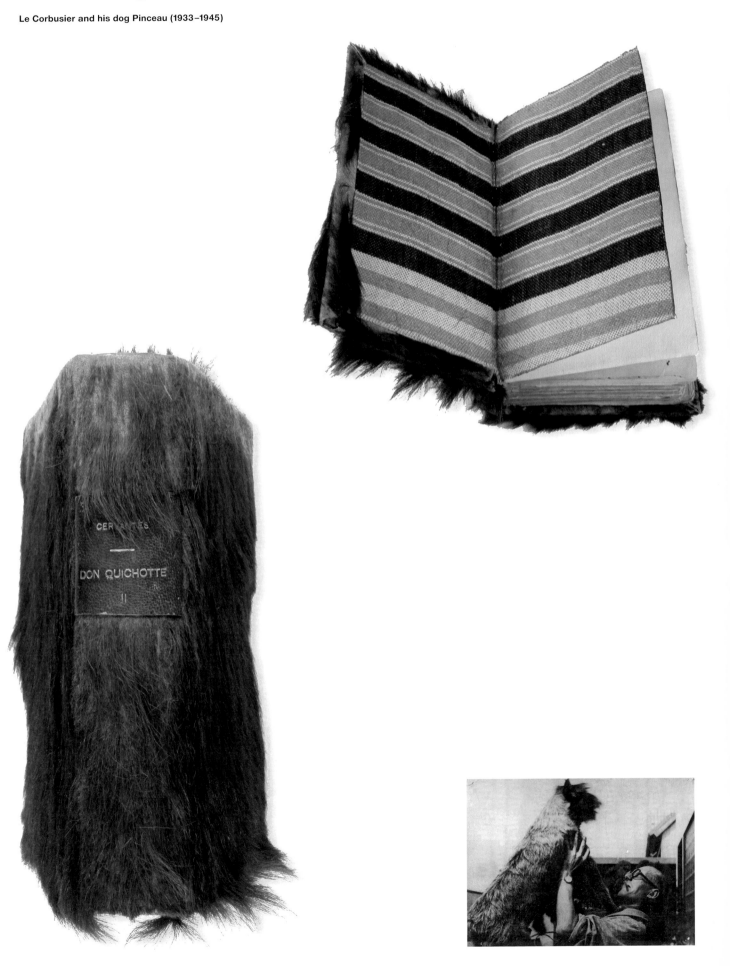

L'Admirable Don Quichotte de la Mancha
A book from Le Corbusier's personal library,
bound in the hide of his dog, Pinceau

Le Corbusier and his dog Pinceau (1933–1945)

As far as Le Corbusier was concerned, books were a full-fledged part of the "machine society." Right from the 1920s, then, he felt that another traditional French practice was outmoded, namely the cutting of pages. Hand-cutting the folded edge of each page—still practiced by lovers of traditional books—necessarily transforms the edge of the book into an uneven surface that bears the trace of an individual operation carried out with a more-or-less steady hand holding a more-or-less sharp blade. In contrast, the perfectly smooth edge of a machine-trimmed book helps to create clean volumes and an industrial appearance. In a letter to his publisher following publication of *Vers une architecture*, Le Corbusier stated that he thought "the trimmed copies were infinitely better than the untrimmed ones," but he joked that "book-trade folks still like jagged pages." A note to himself, prompted by one of the reprintings of *Vers un architecture*—probably the very next year—read, "Demand that the book be trimmed."[53]

For Le Corbusier, books represented above all a means of dissemination, and were therefore more suited to mass production than to handcrafted or artistic manufacture. This was true even of his plans for small, carefully produced volumes such as the first in the series of Carnets de la Recherche Patiente, published by Girsberger in 1954. Thus he had reason to complain of the limited, numbered edition that the publisher had insisted on producing. "Here," he wrote on the slipcase of one of the hundred copies printed on handmade paper, "the lavish paper discredits everything."[54]

53 Undated, handwritten note by Le Corbusier (FLC, B2-15-164).
54 Le Corbusier's annotation on the cardboard slipcase to copy 33 of *Une petite maison* (Zurich: Girsberger, 1954), now in the Fondation Le Corbusier.

Proposal for the cover of *UN Headquarters*, 1946
Pen and ink, pencil on paper
199 × 153 mm

The cover of the special "Art" issue of
L'Architecture d'aujourd'hui, 1946
310 × 240 mm

UNIFYING AN ŒUVRE THROUGH PUBLICATION

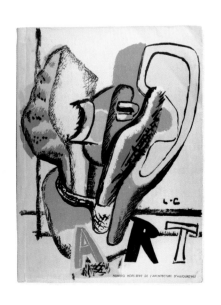

FROM LAYING OUT THE ART TO THE ART OF LAYOUT

Le Corbusier's 1935 book, *La Ville radieuse*, made an initial attempt to relate his painting to his architectural work by reproducing one of his canvases as a frontispiece, accompanied by a comment on the link between these two aspects of his professional activity. But it was only after the Second World War that the architect truly incorporated artworks into his books, alongside his plans for buildings and his urban-development projects. In 1956, a special "art" issue of *L'Architecture d'aujourd'hui* (for which he supplied the cover) gave Le Corbusier the opportunity to publish illustrations of the whole of his œuvre, ranging across all fields. His accompanying text, titled "Ineffable Space," attempted to theorize his approach to art and to describe its unity across all the fields involved.

The principle of heterogeneous imagery evoked in this issue of the magazine was employed again in the book titled *New World of Space* (which also published the "Ineffable Space" essay in English). This time, however, the various aspects of Le Corbusier's œuvre were not presented successively but rather simultaneously, as a way of further stressing their unity. In a preparatory note, Le Corbusier advocated: "On the same page fragments of painting with fragments of a façade, and luscious gouaches with prints and plans of facades."[55]

Thanks to double-page spreads conceived as a coherent space, *New World of Space* generates revealing oppositions. The effect of demonstration is sometimes accentuated by the inclusion of greatly enlarged details of a painting; the shift in scale reveals formal correspondences that would otherwise remain imperceptible without this artifice. Thus we can see, for example, that the curves of the 1930 urban plan for Algiers echoes the motif of an oil painting of the same period, while a fragment of a painting from 1931 seems to be drawn directly from the architectural maquette for an Unité d'Habitation. The implied connections, although often appearing to be the product of conscious effort, sometimes seem to be random, ex-post-facto discoveries that have clearly been "enhanced" by the layout. Books thus became for Le Corbusier the site of an invention that could only have

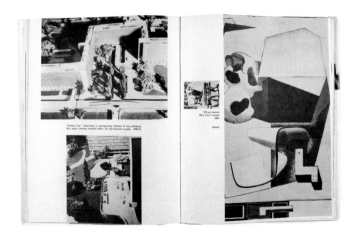
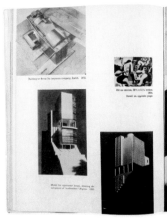

Double-page spreads from *New World of Space*
1948
280 × 220 mm

Page from the special "Corbusier" issue
of *L'Architecture d'aujourd'hui,* 1948
310 × 240 mm

occurred on the printed page – the invention of the unity of his œuvre, which henceforth became the crucial basis of the analysis, presentation, and pursuit of his creative work.

Another special issue of *L'Architecture d'aujourd'hui*, dated 1948, was devoted to Le Corbusier and notably contained a text originally called "Synthèse des arts" (Synthesis of the Arts) but finally titled "Unité" (Unity). It was a direct extension of the task begun with *New World of Space*, proposing a new, more sophisticated version of "synthetic" layouts. Here art, architecture, and town planning were skillfully merged thanks to montage and superimposition effects made possible by new printing techniques. Thus a skyscraper planned for Algiers seems literally incorporated into a painting, while drawings of spiraling, shell-like animal bones form a pattern that partially screens a photograph of the Stein Villa in Garches. Elsewhere, transparent colored shapes – flat areas of yellow, blue, and green – are superimposed on columns of text and images (not unlike paintings by Fernand Léger). Seeking to demonstrate the close links between the diverse fields of architecture, painting, sculpture, and town planning, Le Corbusier came to handle the printed page itself as an artistic medium; the unity of his œuvre found its best argument through a concept that was itself highly creative.

From that point onward, presenting his work from the angle of a synthesis of the arts became an issue in every one of Le Corbusier's books. His 1950 volume on the Modulor system thus suggested links between his visual art and his architecture, both presented here as the fruit of a shared application of harmonious measures. The booklet of 1951, *Poésie sur Alger*, reemployed the principle of flat shapes of color that was tested in 1948, thus transforming his drawings of urban development by handling them like prints. The text itself puts a poetic accent on his reflections on the city, while the cover – handdrawn letters, plus a drawing inspired by Mallarmé – heralds the book's ambitions by suggesting a fusion of art, architecture, and literature.

Two books published in 1954 and 1958 – the first devoted to the house he built for his parents on the shore of Lake Geneva, the second to the chapel at Ronchamp – also display a determination to lift the genre of architectural monograph to the rank of artist's book. Like *Poésie sur Alger*, both of these covers employ handwritten lettering, and *Ronchamp* also includes several enlargements of handwritten notes that thus acquire the twin status of text

and illustration. In the 1954 book, *Une petite maison*, drawings often appear alongside photographs, allowing the author to stress the simultaneously subjective and creative aspect of the project through a constant reminder of handcrafted labor. Furthermore, Le Corbusier printed his own portrait of his mother as the basis of an original visual composition across a double-page spread. In the book on Ronchamp, the series of photographs – more formalist and documentary, featuring cropped framing or unexpected angles – work not so much to give a legible view of the building as to convey the artistic feeling of the site, thereby exploiting the format of the book to lend another dimension to the presentation of the project.

The cover of the special "Corbusier" issue
of *L'Architecture d'aujourd'hui*, 1948
310 × 240 mm

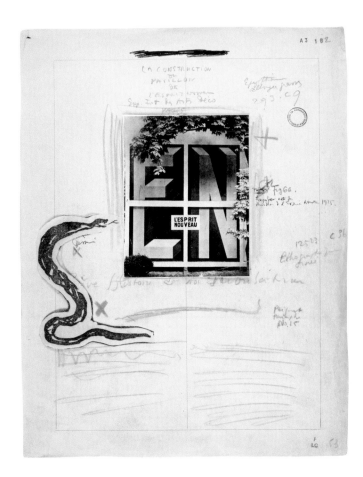

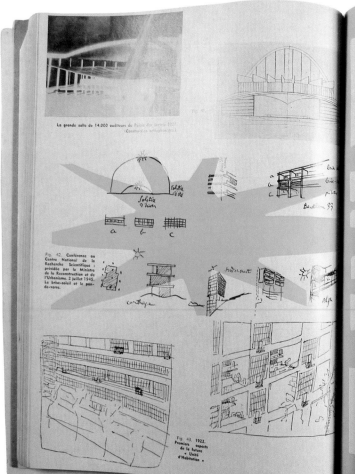

La grande salle de 14.000 auditeurs du Palais des Soviets 1931
(Construction métallique)

Fig. 42. Conférence au Centre National de la Recherche Scientifique ; présidée par le Ministre de la Reconstruction et de l'Urbanisme, 2 juillet 1945. Le brise-soleil et le pan-de-verre.

Fig. 43. 1922. Premiers aspects de la future Unité d'Habitation.

d'amour passionné de l'art ont dû demeurer secrètes, alors qu'on m'accusait de nier l'art et de haïr la peinture. (Vers 1933, le peintre André Lhote m'avisait loyalement qu'il allait engager une campagne contre moi, parce que j'avais la haine de la peinture et que j'interdisais tout achat de peinture à mes clients d'architecture.) Le matin à la peinture, l'après-midi, à l'autre bout de Paris, architecture et urbanisme.

Mesure-t-on à quel point ces jardinage, laboureage, sarclage patients et obstinés des formes et des couleurs, des rythmes et des dosages, alimentaient chaque jour les architectures et les urbanismes qui naissaient 35, rue de Sèvres ? Je pense que si l'on accorde quelque chose à mon œuvre d'architecte c'est à ce labeur secret qu'il faut en attribuer la vertu profonde.

Je soumets ici un fragment d'un tableau de 1920 et le dessin de ce même tableau [1]. Lorsque je le fis, je n'étais pas fier, plongé comme un noyé dans le sentiment de total échec qui accompagne si souvent l'élaboration d'une œuvre. (Fig. 22 et 23).

Vingt-sept années plus tard, l'apport esthétique se dégage. Masses et profils

BRÉSIL

sont d'une diction tranchante. Masses de marbre ou de pierre taillée, mais masse aussi d'édifice, masse de villes mêmes. Profils de métal, de pierre ou de paysage faits de géométrie — qui est l'écriture que l'homme s'est donnée pour prendre possession de l'espace. Des meubles, des maisons ou des villes !

Quelle filiation retrouver à ces profils qui devaient entrer dans mon œuvre bâtie ? En 1910, âgé de vingt-trois ans, j'eus l'insigne bonheur de me trouver pendant un mois sur l'Acropole d'Athènes ; j'y étais arrivé sac au dos, après avoir déroulé une longue spirale à travers l'Europe, au cours de trois années. Circonstance exceptionnelle : la colonnade ouest du Parthénon gisait à terre encore, depuis que l'explosion, au temps des Turcs, l'y avait jetée. Mes yeux, mes mains, mes doigts, pendant quatre semaines, parcoururent les fûts des colonnes, les chapiteaux, les architraves, l'entablement dispersés.

Les doigts, les mains ? Y a-t-il meilleur outil de perception, de lecture, d'appréciation ?

Le mystère de la modénature me fut révélé. Je n'étais pas encore entré dans

(1) Collection privée L.C.

39

**Dummy pages for the special "Corbusier" issue
of *L'Architecture d'aujourd'hui*, 1947–1948
Pencil and collage on paper
310 × 240 mm**

**Pages from the special "Corbusier" issue
of *L'Architecture d'aujourd'hui*, 1948
310 × 240 mm**

Rio-de-Janeiro. Soleil, mer, paysage, urbanisme, architecture.

mille sinistrés de Saint-Dié et
ils étaient prêts à me croire.
Depuis 1945 jusqu'à ce jour
encore (1947), le plan de Saint-
Dié, démontré par de grands
documents photographiques
colorés, circule à travers l'U.
S. A. et le Canada, comme
« témoignage de la renaissan-
ce française ». (Qualification
donnée par les Américains) (1).
Mais on a profité de mon
absence : j'étais engagé dans
une véritable bataille d'où
sortira le Quartier Général
des Nations Unies à New-
York. On mit la politique dans
l'urbanisme. Le plan m'avait
été demandé par quelques
industriels jeunes et pas-
sionnés de Saint Dié qui en
payaient les frais ; le maire

(1) Cette exposition circulante a été or-
ganisée par « Le Walker Art Center »,
de sa propre initiative et indépendam-
ment de moi.

La grotto-ciel, organisme clair,
concentration de la proportion.

Fig. 10. Saint-Dié.

15

12

13

14 POÉSIE SUR ALGER

thétique de l'enthousiasme, de la confiance et de la foi, s'écrivant alors dans les œuvres communautaires, donnant aux entreprises leur force, leur puissance irrésistibles, dressant la ville étincelante debout sur les ternes échecs de ce temps.

※

La poésie rayonne sur Alger : un plan directeur, — le plan directeur — la manifestera.

Elle n'est point subjective mais pétrie de réalité nord-africaine. Le plan directeur dégageant des règles affirme que des sources de joie profondément humaine s'épandront si les ressources du site sont mises au service des hommes (3). Ces joies, depuis quinze ans, je les ai qualifiées d' « es-

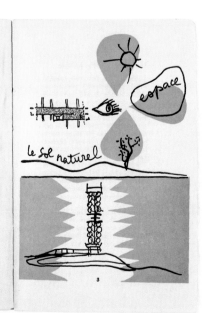

24 POÉSIE SUR ALGER

pentes raides, de rigoles en escalade, d'escaliers (7).

J'étais sur les « Hauts d'Alger », la réserve inestimable, les lieux où se dérouleront les événements urbanistiques de demain, ce tréteau du jeu imminent de l'habitation humaine, le jeu du bonheur possible d'une société ayant dépassé l'âge noir de bêtise et hideur, de paresse et laisser-aller, le jeu nouveau d'un troupeau ayant trouvé des bons bergers.

Cette escalade sur la ligne de plus grande pente, je la désigne comme l'un des axes verticaux d'Alger.

(8) Il en est d'autres encore aussi plaisants, tout au long de la falaise, appuyés sur le bord de la mer, traversant la croûte des bâtisses fâcheuses et tous débouchant dans la lumière...

Celui-ci touche à l'obélisque de

temps de cette conversation, on projetait de construire *un métro, sous terre,* pour conduire vite des populations loin dans des lotissements — au diable vert! On élaborait aussi (10) des plans de boîtes à loyer au pied de la Casbah, sur le terrain « de la Marine », récupéré par la démolition de taudis. Dans le corps d'Afrique française et sur le visage même d'Alger, en plein sur le nez de ce visage, oui, des boîtes à loyer! En ce lieu insigne du sol africain!!! Mésaventure! Inconscience! Insouciance! Anéantissement des valeurs poétiques! Assassinat des poètes!

En ces lieux bas de la ville, et en bordure des flots, dans tout ce port façonné de remblais et d'empierrements où l'eau salée s'infiltre, les palmiers seraient à l'aise, les hauts palmiers des oasis. En forêt, en pal-

10

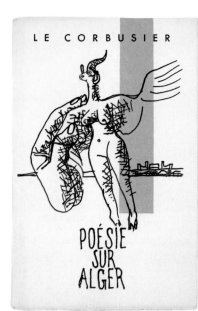

LE CORBUSIER

POÉSIE SUR ALGER

graphie? Le quartier de « la Marine » est menacé? Le cap d'Alger, ce cap d'Afrique sur méridien de Paris, deviendra péché d'urbanisme? (15).

Pèlerin averti de cette terre des miracles possibles, animé d'une foi maintenue indéfectible par treize années occupées à dégager son potentiel urbanistique, je suis venu parler au Gouverneur, au Préfet, au Maire, m'adressant à chacun de ces sommets de la gestion d'une ville, d'une région, d'une Afrique et leur disant :

M. le Gouverneur, M. le Préfet, M. le Maire, la poésie est sur ce lieu qui s'appelle Alger, sur terre d'Afrique où furent une fois et successivement, trois grandes civilisations : la phénicienne, la romaine, la musulmane. Des vestiges, des témoins partout répandus, nous mettent en garde contre la médiocrité de nos entreprises

15

vénales; ils affirment que la grandeur est toujours accessible lorsque règne une pensée UNE.

La page tourne sur la première ère dévastatrice de la civilisation machiniste; la seconde ère s'ouvre dans le feu, le sang, le malheur, — l'ère d'harmonie. Une pensée peut relier les fils de nos entreprises échelonnées dans le temps et l'espace, assurée de les conduire à l'unité.

Le jeu se joue dans le monde entier. Ce ne sont pas des dieux olympiens qui descendront de leur séjour pour venir accomplir chez nous des actes réputés impossibles aux hommes. Ce sont les hommes que vous êtes qui conduiront vers l'Olympe, leur nom, leur mémoire, leur entreprise, par la qualité des initiatives et des responsabilités que vous prendrez (16). C'est entre vos mains : le sort des cinq cent

16

Dummy covers and dummy spreads for *Une petite maison,* 1954
Pencil, pen and inks, collage on paper
167 × 120 mm

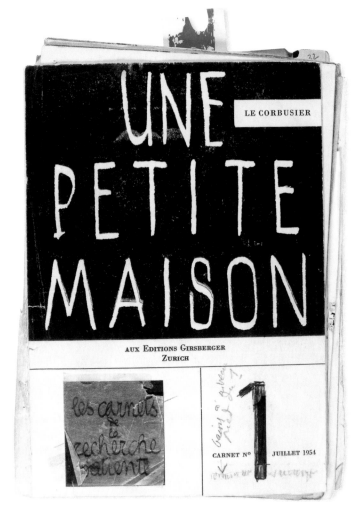

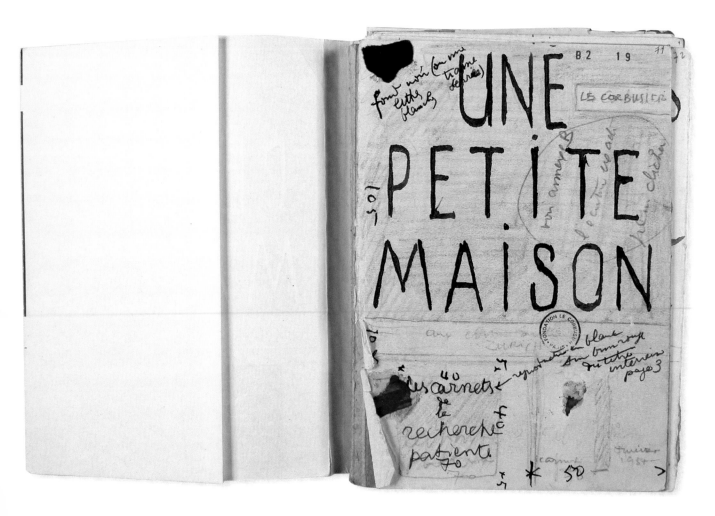

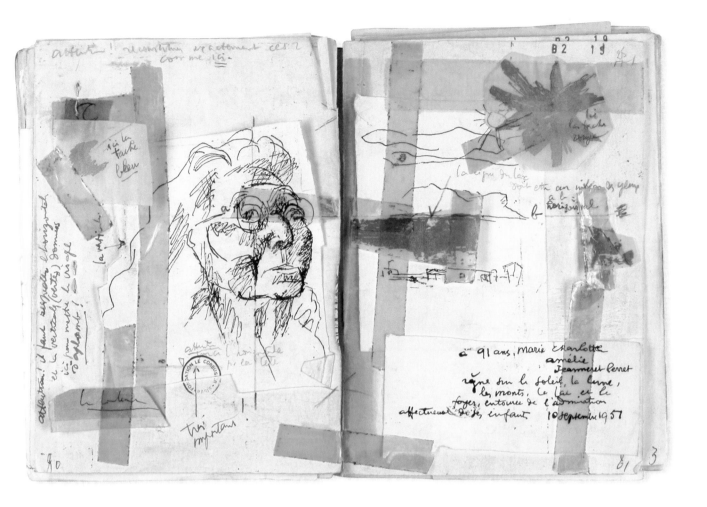

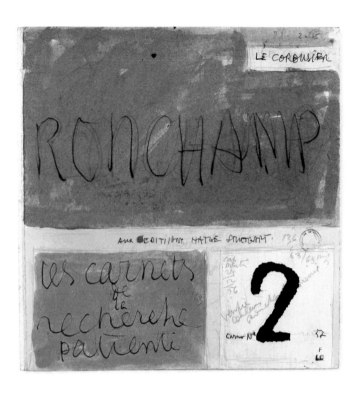

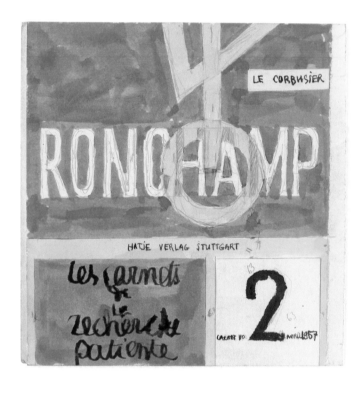

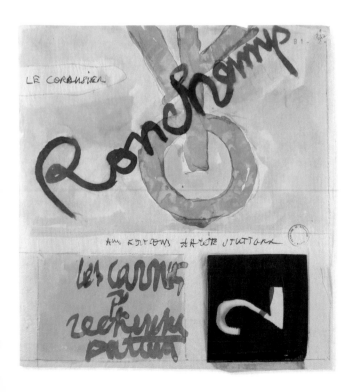

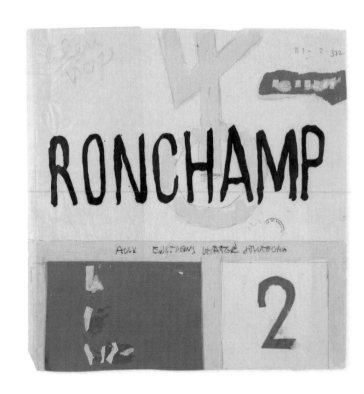

Proposed dust jackets for *Ronchamp*, 1956
Gouache and ink on cardboard
202 × 190 mm

Pages from *Ronchamp*, 1957
205 × 195 mm

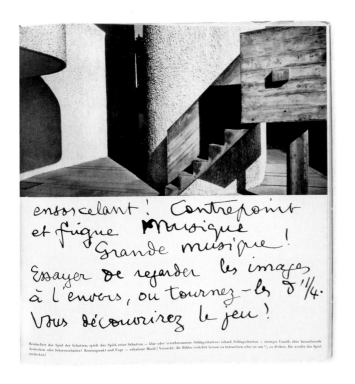

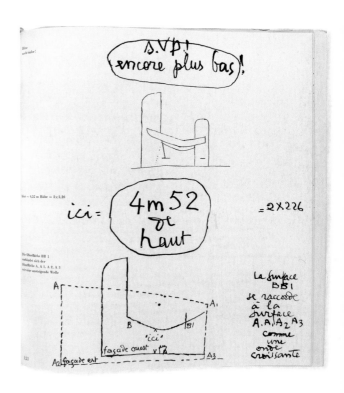

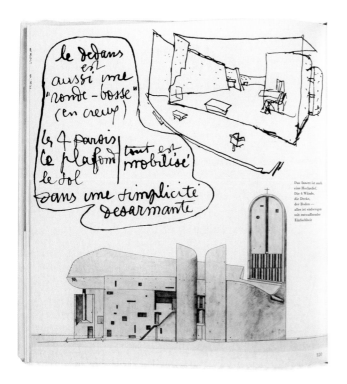

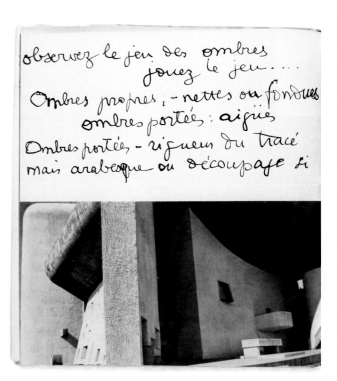

BOOK AS METAPHOR

The lavish, limited-edition portfolio published in 1955, *Le Poème de l'angle droit*, comes across as an art book, an impression reinforced by the series of which it was a part. In contrast, *Les Plans de Paris*, published the very next year by Les Éditions de Minuit, comes across as a rather crude album, printed on ordinary paper and aimed at the widest possible public, as the author himself asserted. Yet it, too, could be seen as an art book, if for different reasons. The first characteristic of this book concerns its content, almost exclusively composed of fragments of earlier books reproduced in facsimile. This principle of editorial salvage was hardly new – back in the days of *Esprit nouveau*, Jeanneret and Ozenfant literally recycled back issues of their magazine, designed from 1923 onwards in such a way as to allow unsold copies to be broken down into separate articles for reuse. This ambitious tactic was known, significantly, by the term *édition-remploi* ("reuse publication").[56] In 1935, *La Ville radieuse* was a compilation of articles already published not only in the magazines *Plans* and *Prélude*, but also in *L'Architecture vivante* and *L'Architecture d'aujourd'hui* – Le Corbusier's bibliography teems with similar examples. *Les Plans de Paris* reused numerous passages from earlier books, notably from *L'Œuvre complète* and *La Ville radieuse*, reprinted in their original layout. For that matter, *Les Plans de Paris* recycled material that had already been reused in *La Ville radieuse*. It was an unending process, analogous to similar developments in other realms involving architectural forms and artworks; indeed, recycling should be seen as one of the wellsprings of Le Corbusier's creative dynamic.

The purely "compilation" aspect of *Les Plans de Paris* was nevertheless enlivened by highlights of color and handwriting that punctuate the pages, constituting the originality of the work (subsequently this visual approach would itself be recycled in the catalogue to the 1962 Le Corbusier exhibition at the Musée National d'Art Moderne in Paris). "Reader," instructs the contents page, "take the green trail and follow it to the end." Handwritten comments are indeed accompanied by green shapes all through the book, forming what Le Corbusier compared to a trail, a kind of "green lane" running throughout the volume. *Les Plans de Paris* was thus constructed in the image of the subject it addressed: the successive layers of the fabric of urban society are reproduced as the reader leafs through pages superimposed on one another, discovering publications from various periods. Hence the reader can adopt the role of a visitor invited to take a quick tour of the premises before diving into a deeper experience of it.

56 See the correspondence between Ozenfant/Jeanneret and Jean Budry (FLC, A1-17-51 to 96).

"Table of contents" from *Le Poème
de l'angle droit,* 1955
420 × 320 mm

Indeed, Le Corbusier had already employed this urban metaphor several years prior to *Les Plans de Paris*, for a book that was never published. He had nevertheless prepared a fairly detailed dummy of *Trente années de silence*,[XXXV] intended for publication by Les Éditions de Minuit to accompany a Corbusier exhibition at the Musée d'Art Moderne in Paris in 1953. Organized in chronological fashion, the plan called for a series of illustrated pages introducing the various sections of the book. On each of these pages was a traffic circle, drawn like a detail from an urban map with a round central space and several radiating streets. The first traffic circle, "Intersection 1," corresponded to the year 1922 and radiated outward to a series of streets, each of which was named: "Town Planning," "Doctrine," "Painting," and "Architecture." An additional street, "Decorative Arts," figured in "Intersection 2," which corresponded to the year 1925. At "Intersection 3" (1939), "Decorative Arts" was replaced by a lane called "Facilities" (which would be retained in Intersections 4 and 5, representing the periods 1940–50 and 1953).[57] Le Corbusier thus devised a visual system based on depictions of urban space, used toward autobiographical ends, that would underscore the multiplicity and the convergence of his activities. It is hard to overlook the analogy between these autobiographical "crossroads" and the drawings in Stendhal's *Vie de Henry Brulard* where, from a half-circle corresponding to the "moment of birth" Stendhal draws several roads, including ones named "madness," "the art of getting read," and "public esteem."[58]

The contents page of *Poème de l'angle droit* also employs an example of a form that metaphorically alludes to the author's architectural activities. Conceived as a hopscotch pattern, this illustration offers a synthesis of the book's contents. It simultaneously represents a rational presentation of information (if the figure is viewed as a set of columns and rows constituting a chart), a symbolic reference to cosmogony (if the connotations linked to the pattern are considered), and an allusion to architectural space (if the pattern is viewed as the floor plan of a building). The bibliography in *L'Atelier de la recherche patiente*[XXXVI] also seems to reflect a spatial conception – the various titles are often arranged within a vast grid covering the totality of the surface of the double-page spread, forming so many boxes – which Le Corbusier calls, precisely, "pigeonholes"[59] – where each book can be symbolically stored.

57 Handwritten dummy (FLC, B3-7- 566).
58 Stendhal, *Vie de Henry Brulard,* in *Œuvres complètes* (Paris: Gallimard-La Pléiade, 1982), II: 671 and 813.
59 "Casier" in French; see Le Corbusier's letter to Gerd Hatje, September 12, 1960 (FLC, U3-1- 137).

XXXV Thirty Years of Silence
XXXVI *Creation is a Patient Search*, trans. James Palmes (New York: Praeger, 1960).

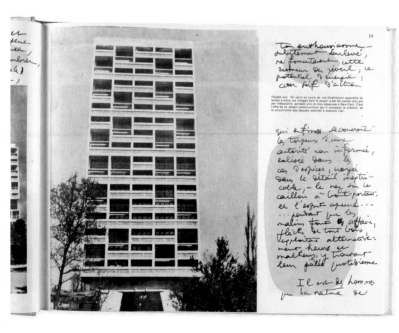

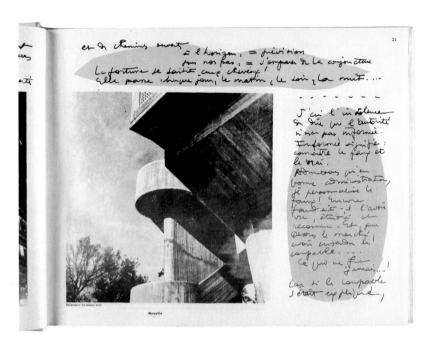

Splendeur du béton brut

Marseille

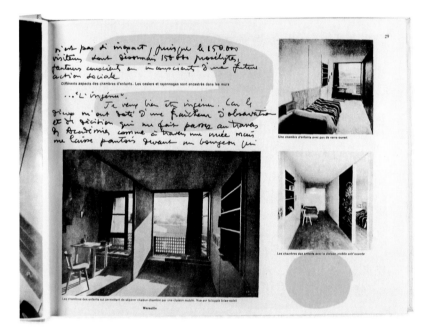

Différents aspects des chambres d'enfants. Les casiers et rayonnages sont encastrés dans les murs

Une chambre d'enfants avec pan de verre ouvert

Les chambres des enfants avec la cloison mobile entr'ouverte

Les chambres des enfants qui permettent de séparer chaque chambre par une cloison mobile. Vue sur la loggia brise-soleil

Marseille

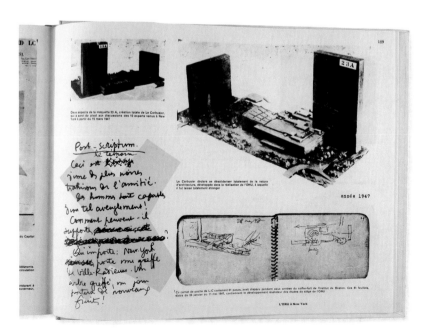

Deux aspects de la maquette 23 A, création totale de Le Corbusier, qui a servi de pivot aux discussions des 10 experts venus à New York à partir du 15 mars 1947

Le Corbusier déclare se désolidariser totalement de la nature d'architecture, développée dans la réalisation de l'ONU, à laquelle il fut laissé totalement étranger

année 1947

¹ Ce carnet de poche de L-C contenait 84 pages, avait disparu pendant deux années du coffre-fort de l'Institut de Boston. Ces 84 feuillets, datés du 28 janvier au 11 mai 1947, contiennent le développement réalisateur des études du siège de l'ONU

L'ONU à New York

Dummiy for *Trente années de silence and
L'Espace Indicible* (books never produced)
1953–1958
Pencil, pen and ink, and pastel on paper
165 × 120 mm

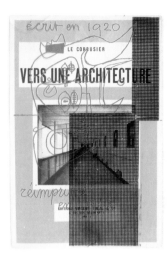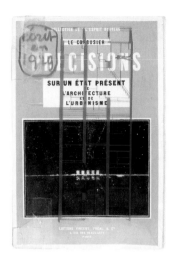

Facsimile cover and transparent silkscreened
dust jacket of *Vers une architecture,* 1958
Facsimile of the 1923 edition
240 × 150 mm

Facsimile cover and transparent silkscreened
dust jacket of *Précisions sur un état présent
de l'architecture et de l'urbanisme,* 1960
Facsimile of the 1930 edition
240 × 150 mm

Facsimile cover and transparent silkscreened
dust jacket of *L'Art décoratif d'aujourd'hui*
1959
Facsimile of the 1925 edition
240 × 150 mm

60 Le Corbusier, "Polychromie architecturale"
[1931], in Rüegg, *Polychromie architecturale...,* 95-
141; "Sainte alliance des arts majeurs ou le grand
art en gésine," *La Bête noire* 4 (July 1, 1935), n. p.;
"L'Espace indicible," *L'Architecture d'aujourd'hui,*
special "Art" issue (Nov.-Dec. 1946), 9-10; "Y a-t-il
une crise de l'art?" *Comprendre* 4 (1951), reprint-
ed in Petit, *Le Corbusier lui-même,* 165-170.

AUTOBIOGRAPHICAL ANGLE

The question of new editions presented Le Corbusier with a specific prob-
lem in the 1950s – how to imbue old books with new life and stress the
topicality of ideas developed decades earlier. The solution adopted for the
three titles dating from the 1920s entailed a graphic response that man-
aged to preserve the original covers – reproduced in facsimile, as were the
inner pages of the books – while giving them a new appearance by adding
a transparent dust jacket, silkscreened in red or yellow with a line drawing
(which represented one of Le Corbusier's interests at the time). These illus-
trations could thus be placed over the original version of the cover without
hiding it. A figure from his *Bull* series (part of Le Corbusier's artistic reper-
toire in the 1950s) was used for *Vers une architecture,* while a silhouette
of the *Open Hand* (destined to become a monumental sculpture in Chandi-
garh) graced *L'Art décoratif d'aujourd'hui,* and a section of the Unité
d'Habitation in Firminy adorned *Précisions.* The impact of the original
cover's imagery – a cruise ship in perspective, a low-angle shot of the Eiffel
tower, a skyscraper against a starry sky – gained in modernity, while the
modern motifs gained greater depth. Artist and architect, new work and
old, were thereby united – hence these new editions suggested, via purely
visual techniques, the career-long synthesis that the author wanted to
convey.

Le Corbusier's mastery of graphic techniques steadily emboldened him
to exercise his artistic skills more fully in the very conception of page layout,
concretely using his artistic experience to enhance his overall œuvre. His
publishing activity of the final decades, marked by a look back to the past,
was placed under the sign of synthesis: the synthesis of the arts merged
into a synthesis of a personal life. This development sheds light and lends
autobiographical significance to the theme of the unity of the arts, as labo-
riously elaborated by Le Corbusier over a thirty-year period via his evolving,
politico-aesthetic thesis (from the "architectural polychromy" of 1931
through the "holy alliance" of 1935 and the "ineffable space" of 1946 right
up to the "coordination between the arts" of the 1950s).[60] By stripping the
ideological function and social dimension from the concept of a synthesis
of the arts, Le Corbusier transformed it into a strictly personal proclama-
tion – it was no longer a question of militating for a synthesis of the arts,
but of asserting that it had occurred through the sole agency of the printed
page (and its artistic layout), thereby justifying an entire life's work.

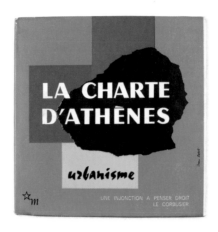

The cover (dust jacket) and a page from *La Charte d'Athènes: Urbanisme des CIAM*, 1957
Republication of the 1943 book
Layout and publication by Jean Petit
210 × 210 mm

Detail of pages from *Le livre de Ronchamp*, conveying the image associated with Jean Petit's Forces Vives imprint, 1961
Designed, edited, and published by Jean Petit

61 This tree is reproduced in *La Maison des hommes*, 137. Le Corbusier himself used it again for the dust jacket of the new edition of *La Ville radieuse*, published by Vincent & Fréal in 1964.

JEAN PETIT'S ELABORATION OF A "CORBUSIER" STYLE

The books produced by Jean Petit largely helped to promote a specific style associated with Le Corbusier's image. Rightly so, in so far as the features of the design of the books issued by the Forces Vives imprint were directly inspired by Le Corbusier's œuvre. From 1955 onward, once Petit abandoned the fleur-de-lis that had adorned his stationery, the graphic image of the imprint was based specifically on Corbusian icons.

The name of the imprint – also the title of a magazine up to 1955 – progressively became associated with various elements that went into forging the publisher's image: starting with *La Chapelle Notre-Dame-du-Haut* (1956), the nearly square format inspired by the two Modulor books would assume various sizes over the years, yielding – in order of increasing size – Micro-Carnets ("Mini-Notepads"), Carnets ("Notepads"), Cahiers ("Notebooks"), and Panoramas. Then there was a quote from Charles Péguy, usually printed without attribution ("You should always say what you see, and above all, something even more difficult, you should always see what you see"). Finally, the imprint appropriated two drawings from Le Corbusier's visual repertoire. The first drawing showed the outline of a tree, with regular, rounded branches.[61] Already used for a 1955 issue of *Forces vives*, it would serve as the logo for the series right up to the final books published by Petit in the 1990s. The second drawing, a squared spiral, derived from a sketch for Le Corbusier's projected "museum of unlimited growth," became part of the Forces Vives image in 1961 when Petit founded his own publishing house, Éditec.

In addition to this overall image that implied Le Corbusier's symbolic sponsorship of the Forces Vives series, Petit's books borrowed the architect's aesthetics. The dust jackets for *La Charte d'Athènes and Entretien*, for example, were adorned with original compositions (patently signed by Petit), based on the paper cutout technique, thereby drawing on a technique and formal vocabulary used by Le Corbusier in his own artwork. The titles of the main sections of *La Charte d'Athènes* are placed inside irregular cartouches with jagged edges, as derived from *Poème de l'angle droit*. Furthermore, on several occasions Petit made use of handwritten lettering (the title pages of *Entretien*, the covers of *Poème électronique* and *Mise au point*) and autograph signatures, just like Le Corbusier. He also used various drawings by Le Corbusier to decorate covers and dust jackets, or to serve as frontispieces or tailpieces inside the books: a spiral shell (directly taken from an illustration in *Entretien*), the leaf of a tree (a simplification of an

The cover of *La Chapelle Notre-Dame du Haut, Ronchamp,* 1956
Layout and publication by Jean Petit
200 × 200 mm

The cover of *Le livre de Ronchamp,* 1961
Layout and publication by Jean Petit
210 × 210 mm

The cover and dust jacket of *Les Trois Établissements humains,* 1959
Republication of the 1945 book
Layout and publication by Jean Petit
210 × 210 mm

The cover of *Le Corbusier lui-même,* 1970
Text, layout, and publication by Jean Petit
275 × 275 mm

early drawing), a star and flower (taken from stained-glass motifs in the chapel of Ronchamp), a shaft of lightning (redrawn for *Poème électronique* but already present in *New World of Space*), an open hand, and so on. These transformations were an extension of Le Corbusier's own practice of elaborating simple, easily recognizable figures to symbolize certain aspects of his theory or œuvre; he had long been familiar with modern techniques of visual communication (as witnessed by the ASCORAL logo and the Modulor figure with raised arm, which appeared often and in various guises – printed, painted, cast in concrete – not to mention the many "signs" in the tapestries at Chandigarh).

After 1965, Petit adopted the stencil-letter typeface, Chaillot, designed by Jacno and employed by Le Corbusier for the cover of *Les Plans de Paris*; Petit used it for the initials LC on the front cover of his biography, *Corbusier lui-même* (1970), and on the various documents he designed for the Fondation Le Corbusier. Chaillot was also used on the dust jacket of *BSGDG* (1996), other stencil-lettering being used, for example, on the cover of *Le Corbusier parle* (1967) and *Bonjour Monsieur Le Corbusier* (1988). For the 1970 biography, Petit was inspired by Le Corbusier's interest in automobiles – the architect designed one in 1928 in collaboration with Pierre Jeanneret – to come up with a layout that linked each chronological stage of the architect's career with a picture of a period car, thereby providing a visual record of the evolution of automotive design (an example of which had already been included in *La Ville radieuse*[62]). The irregular if vaguely round green shape set against the white ground on the cover of *Voyage d'Orient*, conceived along the same lines as the dust jacket for the new edition of *Trois Établissements humains*, seems taken directly from a page in *Les Plans de Paris*. Petit would continue to use this approach on covers for later publications unrelated to Le Corbusier, thereby branding them with the Carnets Forces Vives imprint (as distinct from Micro-Carnets and Cahiers), and it is worth noting that the dust jackets of the various volumes of Le Corbusier's *Œuvre complète* on sale today are still composed along similar lines (the colored shape being bright red in this case).

Furthermore, some of Petit's books on Le Corbusier (prior to 1965) sought to transpose "architectural polychromy" onto the print medium by reusing colors from the architect's palette for flyleaves and title pages. This exercise of translating one medium into another seems to have been one of the highlights of Petit's contribution to his partnership with Le Corbusier. The most remarkable layout produced by Petit remains, without a doubt, the one

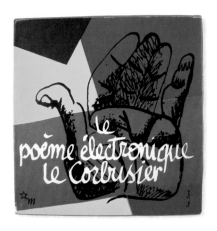 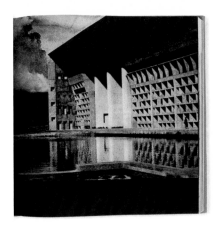

The cover and pages from *Le Poème électronique,* 1958
Layout and publication by Jean Petit
210 × 210 mm

63 Born in 1925, Robert Massin, like
Faucheux, worked as the art director of
various book clubs in the late 1940s
and early 1950s, then pursued this career
with Gallimard.
64 Willem Sandberg, born in 1897, died in
1984. He was not only a graphic designer but
also director of the Stedelijk Museum in
Amsterdam from 1945 to 1963. Paul Rand,
born in 1914, died in 1996. A key figure in
American graphic design of the latter half of
the twentieth century, he notably designed
IBM's famous striped logo.

for *Le Poème électronique*, a monograph on the Philips Pavilion built by
Le Corbusier and Xenakis for the Brussels World Fair of 1958. The fifty-six
pages devoted to the "electronic poem" itself – an eight-minute show of
visuals conceived by Le Corbusier with music by Edgard Varèse – represents
a particularly interesting sequence from a graphics standpoint. Petit's
highly active participation in all stages of the development of the poem,
from picture research to the transcription of the final running time, certainly
played an important role in the success of the book as a reliable record
of the show.

Thanks to an ambiguity deliberately cultivated by both parties, Petit's
books on Le Corbusier could pass for books by Le Corbusier himself,
graphically designed by the architect. The confusion was further fueled by
Le Corbusier's habit of always producing the dummies of his own books.
Petit thus embodied a necessary transition that allowed Corbusier's book-
design aesthetic to become totally identified with the style of the 1950s
and early 1960s. Pierre Faucheux, despite his closeness to Le Corbusier
and despite having worked for him, could never have played the same role
as Petit, given Faucheux's strong personality and creative impulse; Petit's
own career, for that matter, would prove to be extremely slight compared
to Faucheux's. The history of graphic design accords no place – for the
moment, at least – to Jean Petit, whose work as a designer has attracted no
attention apart from this absolutely unique partnership with Le Corbusier.
Yet his work on behalf of the architect – notably during the Forces Vives/
Éditions du Minuit collaboration – was crucial in concretizing the latter's
editorial image at a time when French publishing was just emerging from its
graphic torpor.

Numerous shared features emerge from a comparison of the Petit/Corbusier
books with those produced at the same time by Faucheux or Robert
Massin,[63] the two graphic artists most closely associated with the visual
rejuvenation of French publishing in the postwar period. Connections to
the creative graphic art of the day extend beyond the borders of France,
however. Clear similarities can be detected with certain aspects of the
work of the Dutchman Willem Sandberg and the American Paul Rand in the
late 1950s and early 1960s.[64]

At that time, Rand was already advocating the virtues of reversing black
on white, using handwritten text, and arranging cut-out shapes of colored
paper to produce abstract compositions, as had Le Corbusier. The archi-

tect was a key source for Rand, who quoted him on many occasions in his own texts and who advised his many generations of students to read Le Corbusier.[65] Rand was notably interested in the grid suggested by the Modulor, which he felt was the least constraining of all the systems of proportion.[66] This influence of Le Corbusier's work is not without a certain irony if we recall his dismissal of avant-garde experimentation, his insensitivity to typographical innovation, and his wariness of the validity of Swiss graphic art, all of which served to inspire a creative artist such as Rand. Like many designers, however, Rand also turned to architects for models, and he performed a kind of synthesis of elements drawn from multiple sources – his designs were heavily steeped in the work of French artists such as Picasso, Léger, and Matisse, whose work also played a major role in Le Corbusier's visual art. It was via this indirect path and this historical filter that Le Corbusier's œuvre would ultimately converge with the work of one of the most striking graphic designers of the latter half of the twentieth century.

65 Jessica Helfand, "Paul Rand, The Modern Designer," and "Paul Rand, The Modern Professor," in Screen: Essays on Graphic Design, New Media, and Visual Culture (Princeton: Princeton Architectural Press, 2001), 137-163; Steven Heller (ed.), Paul Rand (London: Phaidon, 1999).
66 Paul Rand, A Designer's Art (New Haven/London: Yale University Press, 1985), 194. Rand met Le Corbusier at least once, and often recounted this meeting with his mentor. Note that some of Rand's first commissions, from 1938 to 1945, were for covers of the magazine Direction, founded by Le Corbusier's American mistress, Marguerite Tjader-Harris. On Rand's meeting with Le Corbusier, see Helfand, "Paul Rand, the Modern Professor," 151; on Rand's work for Direction, see Heller, Paul Rand, 26-31.

MACHINE-AGE BOOKS

SYNTHESIZING THE ARTS: THE PROOF IS ON THE PAGE

"Obviously, the problem is to cut through the complexities, to attain simplicity. To cut through the chaos of life, to pursue a compelling dream: not the one of remaining young, but of becoming young."[67] The quest for that "compelling dream" probably explains the constant return to the past that dominates the books published by Le Corbusier after the war – it was a question of taking a new look at earlier works in order to demonstrate their ever-renewable relevance. Without a doubt, Le Corbusier's aim was to make sure his work never became outdated. For he realized that merely husbanding his acquired fame or sustaining his creative impetus in multiple fields right to his dying breath would not necessary suffice to insure that his posthumous image would remain eternally fresh. Having always struggled himself, down through the years, to devise new approaches to publications that would present his work as being in harmony with the spirit and the resources of the day, he now wanted to organize his succession and train the person who would take over after he was gone – Jean Petit and the Forces Vives imprint.

The abundant illustrations in the books from the 1920s and 1930s were characterized by a great variety of images drawn from multiple sources. They included, pell-mell, photographs of animals, buildings, everyday objects, clippings from newspapers and sales catalogues, cartoons, old-master paintings, scientific diagrams, and so on. Later, this teeming, diverse illustration in the early decades – which, in a way, embraced the variety of the world – became more focused by concentrating on the author's own artistic universe. The graphic strategies adopted by Le Corbusier henceforth aimed to exhibit his œuvre in a way that simultaneously demonstrated its diversity (architecture, town planning, painting, sculpture) and its unity (the "common denominator"[68]). The printed page provided the most congenial space for demonstrating the synthesis of his activities: it could reproduce all his works, using the resources of page layout and printing techniques to juxtapose (and occasionally superimpose) photographic views of buildings, plans of urban development, drawings, sketches, paintings, and sculpture. Books allowed Le Corbusier to underscore both synchrony and linear heritage, alternately employing these two models to govern the arrangement of illustrations. In this respect, Le Corbusier's books came to constitute an

67 W. Boesiger (ed.), *Le Corbusier: Œuvre complète* (Zurich: Girsberger, 1957), VI: 9, translated by William B. Gleckman, slightly revised here.
68 Ibid.

"imaginary museum" of his personal œuvre, through which readers would be guided along a path determined by the sequence of pages and their internal organization. Freed from all constraints of scale, the objects assembled on the page revealed the secret links connecting them and the invisible details of their composition. Yet it was not only as a unifying support that books could function as the most accomplished expression of the difficult "synthesis of the arts" whose rules Le Corbusier had tried to establish throughout his life. Publications also allowed Le Corbusier to present, through reiterated visual affirmations, the path of his personal career as the progressive recovery of a lost unity. The publishing process that presided over this reassembly – the putting together, in the broadest sense, of a book – called upon in equal measure the skills of architect, artist, and writer, all mobilized toward a new creative act.

AN OBJECT, A WORK, A PRODUCT

Le Corbusier never forgot that a book is first and foremost a volume. He worked at simplifying the representation of this object, which had been one of the "modest pictorial motifs"[69] of Purist paintings; this identifiable shape would evolve into the icon that Le Corbusier sketched every time he wanted to indicate a plan for a book in his notes or on the cover of a preparatory folder. This image of an open book is found in the plans for the illustrated cover of *La Charte d'Athènes*, in a title page for *Modulor 2*, and, in the form of what Le Corbusier would call a "pictogram," in *L'Atelier de la recherche patiente*. The three-dimensional aspect of a book would also be represented in the illustrated bibliography of *Les Plans de Paris* (itself derived from another one in the fourth volume of *L'Œuvre complète*), in which the frontal photograph of each cover is accompanied by a perspective sketch of the edge of the book. At the very start of each new publishing project, Le Corbusier mulled over the form he would give to the book, notably its dimensions, to be determined as a function of the subject matter – he experimented with all kinds of formats. No decision was left to chance. Choice of paper, selection of typeface and fonts, spacing, typographical layout, placing of illustrations – the tiniest feature of book design was meticulously assessed.

Although some of Le Corbusier's books flaunt their creative side more than others, in every case the author mobilized his own artistic resources. He always designed the covers and dust jackets of his books, which display obvious analogies to various formal aspects of his visual art – paper cutouts, the use of curved elements to inflect rectilinear compositions, and the

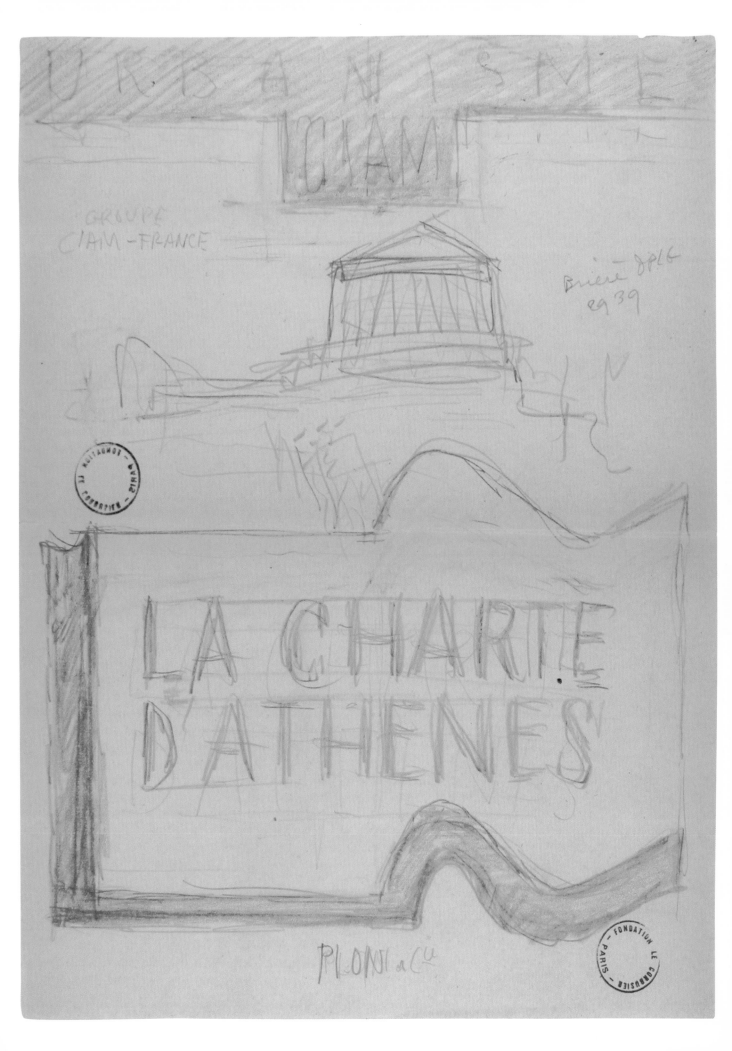

merging of the two registers of industrial standardization and individual
expressiveness through contrast of typeset text with handwritten notes.
More profoundly, collage and recycling-type techniques were employed by
Le Corbusier in his books just as they were in his architectural plans and
his artwork. Reuse would thus appear to be one of the foundations of his
personal creative dynamic. From this standpoint, *Les Plans de Paris* comes
across as a paradigmatic Corbusian work: made in the image of the subject
it discusses – a composite, stratified city – *Les Plans de Paris* was designed
to function on a metaphorical level. It thereby prefigured numerous books
on architecture and urban philosophy that were published in the latter half
of the twentieth century. *Collage City* by Colin Rowe and Fred Koetter comes
to mind with its composite illustrations, as does *Learning from Las Vegas*
by Denise Scott-Brown, Robert Venturi, and Steven Izenour, with its
arrangement of Vegas strip-inspired photographs indebted to Ed Ruscha.
And then of course there were Rem Koolhaas's books, ranging from the
structure of *Delirious New York*, conceived as a series of blocks simulating
the grid of Manhattan to the ephemeral, cheap, and disposable form of
Content, via the monumental, variegated accumulation of 1,344 pages in *S,
M, L, XL*.[70]

Book design was an activity as natural as it was essential to Le Corbusier,
to whom everything would appear, sooner or later, as a potential subject for
a book. Study of his abundant publishing output enriches our appreciation
not only of the creative side of his work, but also his role as entrepreneur,
as deviser of grand projects, as tireless globe-trotter, and as businessman
in perpetual search of new markets. Indeed, Le Corbusier wanted to take
charge of every step of the production process – he viewed his books as
commercial products and he devised ways of improving their sale. Finally,
in conjunction with Jean Petit he anticipated the future of his posthumous
publications, hoping that they – like his ideal museum – would enjoy limitless
growth.

LE CORBUSIER AS "REFORMER"?

In 1962 Le Corbusier met the Crommelynck brothers, who were art publish-
ers. But he was unable to find common ground with the "thoroughbred
craftsmen" who, he claimed, were blinded by a pointless quest for a total
respect for tradition, which was "costly, meticulous, and difficult." They also
advocated production methods that were too conventional for his taste.
"I showed them a mock-up that is pretty sharp. It could be produced with

70 Colin Rowe, Fred Koetter, *Collage City* (Cam-
bridge, Mass: MIT Press, 1977); Robert Venturi,
Denise Scott Brown, Steven Izenour, *Learning
from Las Vegas* (Cambridge, Mass./London, MIT
Press, 1972), designed by Muriel Cooper; Rem
Koolhaas, *Delirious New York* (New York: Oxford
University Press, 1978); Rem Koolhaas, OMA,
Content (Cologne: Taschen, 2004); Rem Koolhaas,
Bruce Mau, OMA, *S, M, L, XL*, (New York: Mona-
celli Press/Rotterdam: 010 Publishers, 1995).
Concerning the layout of this last volume, see my
article, "Je suis un livre: À propos de *S, M, L, XL*,
de Rem Koolhaas et Bruce Mau," *Les Cahiers du
Musée national d'art moderne* 68 (summer 1999),
94–111.

Detail of a page in *L'Atelier de la recherche patiente,* 1960

A page from *Modulor 2,* 1955
145 × 145 mm

techniques other than etching and aquatint. In Crommelynck eyes, though, that would mean betraying their craft. But reformers are always builders who begin by demolishing and who then build on top." [71] The traditional distinction between art publishing and trade publishing was not an operative one for Le Corbusier, who took as much care with a book printed by offset technology as he did with one produced by lithographic technique, the former process having the additional advantage of the mass dissemination appropriate to the "machine society."

Recognition of Le Corbusier's conservative positions in the realm of publishing, notably when it came to typography, should therefore be tempered by an acknowledgment of the less conventional aspects of his output. When French publishers finally awakened to the modern movement after the war ended, Le Corbusier already had some twenty-five publications behind him, almost all illustrated ones, in which he probably addressed far more issues of design than most French authors of the day. Within the French context, the results of Le Corbusier's unusual attentiveness to the visual dimension of his books inevitably came to the attention of industry professionals. It is legitimate to ask, for example, whether Pierre Faucheux, in addition to his confessed adoption of regulating lines and Modulor proportions as compositional tools, also borrowed Le Corbusier's penchant for reproducing handwritten texts, which became one of the distinguishing features of Faucheux's designs. On another level, it might be wondered whether Roland Barthes, who wrote part of his *Roland Barthes by Roland Barthes* in the third person, referring to himself as "R.B.," had read *L'Atelier de la recherche patiente*, an autobiography devoid of the least "I," Le Corbusier never referring to himself in any way other than by his initials, L.C.[72]

In 1967 Jorge Luis Borges and Adolpho Bioy Cesares ironically dedicated their *Chronicle of Bustos Domecq* to three great "forgotten" figures: "Picasso, Joyce, and Le Corbusier." Although Le Corbusier has in fact become the modern icon we know today – the least forgotten architect of the twentieth century – not all aspects of his œuvre have sparked the same interest despite the efforts he made to draw the public's attention to all of his activities – "tapestries, drawings, paintings, sculpture, books, houses, and city plans are merely, as far as I am personally concerned, one and the same manifestation of a stimulating harmony within the new, machine society." [73] It would therefore seem appropriate to pay closer heed to that special item listed very precisely between "sculpture" and "houses," between art and architecture – Le Corbusier's books.

71 Letter from Le Corbusier to Hermine Chastanet, February 5, 1962 (FLC, U2-1-113).
72 *Roland Barthes by Roland Barthes*, translated by Richard Howard (New York: Hill & Wang, 1977).
73 Le Corbusier, "Tapisserie Muralnomad," *Zodiac 7* (1960), reprinted in (Paris: Fondation Le Corbusier-Philippe Sers, 1987), 14.

Le Corbusier and *Le Poème de l'angle droit*, around 1955

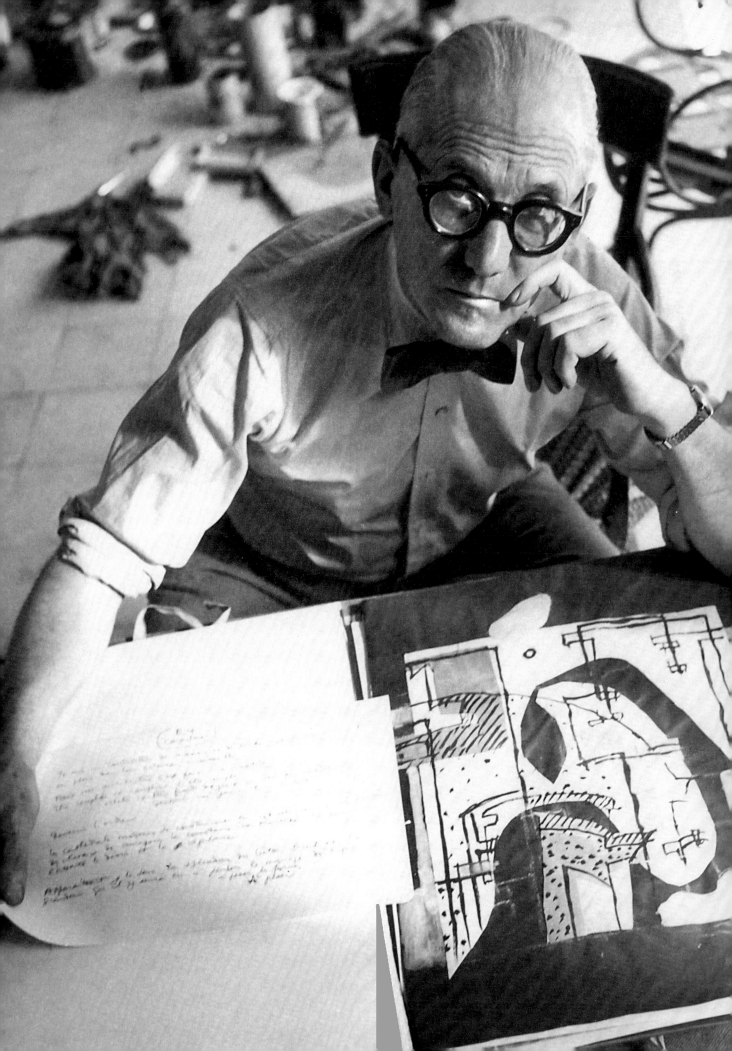

MONOGRAPHS BY LE CORBUSIER, 1912–1960

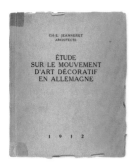

Étude sur le mouvement d'art décoratif en Allemagne
La Chaux-de-Fonds: Haefli & Cie., 1912
200 × 165 mm, 74 pages

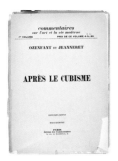

Après le cubisme
Paris: Édition des Commentaires, 1918
185 × 135 mm, 60 pages of text followed by an unpaginated set of illustrations
Coauthor: Amédée Ozenfant

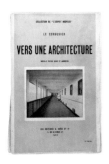

Vers une architecture
Paris: Crès & Cie., 1923
240 × 150 mm, 245 pages
An Esprit Nouveau book

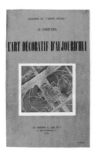

L'Art décoratif d'aujourd'hui
Paris: Crès & Cie., 1925
240 × 150 mm, 219 pages
An Esprit Nouveau book

La peinture moderne
Paris: Crès & Cie., 1925
240 × 150 mm, 173 pages of text followed by an unpaginated set of illustrations
An Esprit Nouveau book
Coauthor: Amédée Ozenfant

Urbanisme
Paris: Crès & Cie., 1925
240 × 150 mm, 295 pages
An Esprit Nouveau book

L'Almanach d'architecture moderne
Paris: Crès & Cie., 1926
240 × 150 mm, 201 pages
An Esprit Nouveau book

Une Maison – un palais
Paris: Crès & Cie., 1928
240 × 150 mm, 229 pages
An Esprit Nouveau book

Précisions sur un état présent de l'architecture et de l'urbanisme
Paris: Crès & Cie., 1930
240 × 150 mm, 271 pages
An Esprit Nouveau book

*Mundaneum**
Brussels: Les Associations Internationales, Palais Mondial (Publication n° 128), 1928
240 × 180 mm, 46 pages + 28 pages n.p.
("A call for all participation")
Coauthor: Paul Otlet

*Requête à M. le Président de la Société des Nations**
Paris: Imprimerie Union, 1931
240 × 160 mm, 26 pages + 10 pages n.p.
("Appendix: Visual documentation providing proof of plagiarism")
Coauthor: Pierre Jeanneret

* Titles marked with an asterisk were not included in the list of thirty-five books drawn up by Le Corbusier in 1960.

1

*Claviers de couleur**
Basel: Salubra, 1931
236 × 29 mm
(catalogue of wallpaper)

Croisade, ou le crépuscule des académies
Paris: Crès & Cie., 1933
240 × 150 mm, 88 pages
An Esprit Nouveau book

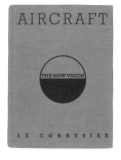

Aircraft
London / New York: The Studio, 1935
250 × 190 mm, 123 pages
A New Vision book

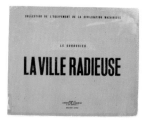

La Ville radieuse
Boulogne: L'Architecture d'Aujourd'hui, 1935
230 × 300 mm, 347 pages
An Équipement de la Civilisation Machiniste
book

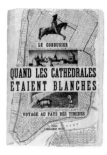

*Quand les cathédrales étaient blanches.
Voyage au pays des timides*
Paris: Plon, 1937
205 × 145 mm, 325 pages

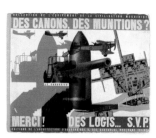

*Des canons, des munitions ? Merci ! Des
logis… S.V.P.*
Boulogne: L'Architecture d'Aujourd'hui, 1938
230 × 300 mm, 148 pages
An Équipement de la Civilisation Machiniste
book

"Le Lyrisme des temps nouveaux et
l'urbanisme"
Le Point, n° XX, 1939
250 × 190 mm, 40 pages

Destin de Paris
Paris / Clermont-Ferrand: Sorlot, 1941
180 × 118 mm, 60 pages
A Préludes book

Sur les quatre routes
Paris: Gallimard, 1941
205 × 140 mm, 237 pages

La Maison des hommes
Paris: Plon, 1942
195 × 140 mm, 209 pages
Coauthor: François de Pierrefeu

Les Constructions murondins
Paris/Clermont-Ferrand: 1942
135 × 225 mm, 34 pages

La Charte d'Athènes
Paris: Plon, 1943
145 × 135 mm, 242 pages

Entretien avec les étudiants des écoles d'architecture
Paris: Denoël, 1943
160 × 120 mm, 61 pages

Les Trois Établissements humains
Paris: Denoël, 1945
160 × 125 mm, 270 pages
An ASCORAL book
Eleven authors

Manière de penser l'urbanisme
Boulogne: Éditions de l'Architecture
d'Aujourd'hui, 1946
223 × 155 mm, 184 pages
An ASCORAL book

Propos d'urbanisme
Boulogne: Bourrelier, 1946
190 × 135 mm, 143 pages
A Perspectives Humaines book

UN Headquarters
New York: Reinhold, 1947
250 × 190 mm, 80 pages

*Grille Ciam d'Urbanisme**
Boulogne: Éditions de l'Architecture
d'Aujourd'hui, 1948
305 × 240 mm, 24 pages

New World of Space
New York: Raynal & Hitchcock, 1948
280 × 220 mm, 128 pages

Le Modulor
Boulogne: Éditions de l'Architecture
d'Aujourd'hui, 1950
145 × 145 mm, 239 pages

"L'Unité d'habitation de Marseille"
Le Point, n° XXXVIII, 1950
250 × 190 mm, 58 pages

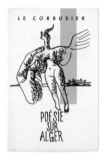

Poésie sur Alger
Paris: Falaize, 1951
170 × 110 mm, 51 pages

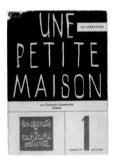

Une petite maison
Zurich: Girsberger, 1954
165 × 120 mm, 87 pages
A Carnets de la Recherche Patiente Book (n° 1)
An additional section at the end includes the
text in German and English

Modulor 2
Boulogne: Éditions de l'Architecture
d'Aujourd'hui, 1955
145 × 145 mm, 344 pages

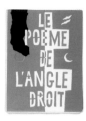

Le Poème de l'angle droit
Paris: Verve, 1955
420 × 320 cm, 157 pages
Portfolio

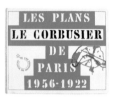

Les Plans de Paris
Paris: Éditions de Minuit, 1956
240 × 300 mm, 192 pages

Ronchamp, Stuttgart: Hatje, 1957
205 × 195 mm, 136 pages
A Carnets de la Recherche Patiente book (n° 2)
The German edition was accompanied by
simultaneous editions in French (Zurich:
Girsberger), English (London: Architectural
Press; New York: Praeger), and Italian (Milan:
Edizioni di Comunita)

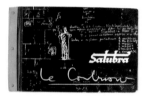

*Claviers de couleur Salubra**
Basel: Salubra, 1959
250 × 400 mm
(catalogue of wallpaper)

Mein Werk / L'Atelier de la recherche patiente
Stuttgart: Hatje, 1960
280 × 220 mm, 312 pages
The German edition was accompanied by
simultaneous editions in French (Paris: Vincent
& Fréal), English (My Work, London: The
Architectural Press, 1960), Spanish (Mi Obra,
Madrid: Nueva Vision, 1960), and Italian (La
Mia Opera, Turin: Boringhieri, 1961)

REPUBLICATIONS
1945–1965

La Charte d'Athènes. Urbanisme des CIAM
Paris: Éditions de Minuit, 1957
210 × 210 mm, 158 pages
A Cahiers Forces Vives book

*Entretien avec les étudiants des écoles
d'architecture*
Paris: Éditions de Minuit, 1957
210 × 210 mm, 158 pages
A Cahiers Forces Vives book

Vers une architecture
Paris: Vincent & Fréal, 1958
Facsimile of the 1923 edition
240 × 150 mm, 245 pages
(+ a 6-page introduction)

L'Art décoratif d'aujourd'hui
Paris: Vincent & Fréal, 1959
Facsimile of the 1925 edition
240 × 150 mm, 219 pages
(+ a 12-page introduction)

Les Trois Établissements humains
Paris: Éditions de Minuit, 1959
210 × 210 mm, 201 pages
A Cahiers Forces Vives book
Edition "devised by Jean Petit"

*Précisions sur un état présent de l'architecture
et de l'urbanisme*, Paris: Vincent & Fréal, 1960
Facsimile of the 1930 edition
240 × 150 mm, 271 pages
(+ a 6-page introduction)

Manière de penser l'urbanisme
Neuchâtel: Gonthier, 1963
180 × 110 mm, 196 pages
A Bibliothèque Médiations book

La Ville radieuse
Paris: Vincent & Fréal, 1964
Facsimile of the 1935 edition
230 × 300 mm, 347 pages
(+ a few additions)

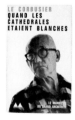

Quand les cathédrales étaient blanches
Neuchâtel: Gonthier, 1965
180 × 110 mm, 248 pages
A Bibliothèque Médiations book

JEAN PETIT'S NEW EDITIONS OF LE CORBUSIER'S BOOKS

La Charte d'Athènes. Urbanisme des CIAM
Paris: Éditions de Minuit, 1957
210 × 210 mm, 158 pages
A Cahiers Forces Vives book

Entretien avec les étudiants des écoles d'architecture
Paris: Éditions de Minuit, 1957
210 × 210 mm, 158 pages
A Cahiers Forces Vives book

Les Trois établissements humains
Paris: Éditions de Minuit, 1959
210 × 210 mm, 201 pages
A Cahiers Forces Vives book
Edition "devised by Jean Petit"
Republished in 1968 and 1990 (Paris: Éditions de Minuit) in a facsimile edition but without the original dust jacket

PETIT'S PUBLICATIONS ON LE CORBUSIER'S ŒUVRE (which include at least one article by Le Corbusier)

"Architecture du bonheur. L'urbanisme est une clef"
Forces vives, n° 5-6-7, 1955
220 × 155 mm, 170 pages
(bears a publisher's imprint: Les Presses d'Île de France)

La Chapelle Notre-Dame du Haut, Ronchamp
Paris: Forces Vives, 1956
200 × 200 mm, 124 pages
A Cahiers Forces Vives book

La Chapelle Notre-Dame du Haut, Ronchamp
Bruges/Paris: Desclée de Brouwer, 1958
255 × 255 mm, 124 pages
A Cahiers Forces Vives book

Le Poème électronique
Paris: Éditions de Minuit, 1958
210 × 210 mm, 244 pages
A Cahiers Forces Vives book

Le livre de Ronchamp
Paris: Éditions de Minuit, 1961
210 × 210 mm, 168 pages
A Cahiers Forces Vives book
Simultaneously published under another imprint: Club du Livre Chrétien (Robert Morel)

Un Couvent de Le Corbusier
Paris: Éditions de Minuit, 1961
210 × 210 mm, 144 pages
A Cahiers Forces Vives book
Simultaneously published under another imprint: Club du Livre Chrétien (Robert Morel)
Simultaneously published in Italian (Milan: Ed. di Comunità)
Republished in 1990 (Éditions de Minuit) in a facsimile edition but without the original dust jacket

Textes et dessins pour Ronchamp
Paris: Éditions Forces vives, 1965
125 × 125 mm, 56 pages
A Micro-Carnets Forces Vives book
Published simultaneously in English by Forces Vives
Republished by the Association Œuvre Notre-Dame du Haut (Ronchamp), 1997 (7th printing)

POSTHUMOUS EDITIONS BY PETIT ALLEGEDLY PREPARED WITH LE CORBUSIER DURING HIS LIFETIME

Mise au point
Paris: Éditions Forces vives, 1966
125 × 125 mm, 61 pages
A Micro-Carnets Forces Vives book
Republished in 1987 with *L'Urbanisme est une clef* (see below)
Text "written by Le Corbusier in July 1965" (p. 5)

Le Voyage d'Orient
Paris: Éditions Forces vives, 1966
165 × 165 mm, 173 pages
A Cahiers Forces Vives book
Republished in 1987 (Marseille: Parenthèses) with a different cover
Text "reread [by Le Corbusier] on July 17, 1965" (flyleaf)

Entre-deux ou propos toujours reliés
Paris: Éditions Forces vives, 1969
435 × 355 mm, Seventeen plates
Book "written and engraved by the author's hand"
Portfolio

La Mer est toujours présente
Paris: Éditions Forces vives, 1968
560 × 500 mm
Book "entirely composed by Le Corbusier"
Portfolio

Le Corbusier dessins
Paris/Geneva: Éditions Forces vives, 1968
275 × 275 mm, 81 pages
A Panoramas Forces Vives book
Book "prepared with Le Corbusier in 1964–1965" and including a "text of 1965 by Le Corbusier, written specially for this volume" (p. 80)

Le Corbusier lui-même
Geneva: Rousseau, 1970
275 × 275 mm, 284 pages
A Panoramas Forces Vives book
Book "annotated and augmented by Le Corbusier during the final weeks of his life" (p. 8)

Contributor to:
Kinder der Strahlenden Stadt/Les Maternelles vous parlent
Stuttgart: Gerd Hatje, 1968
(Teufen, Arthur Niggli, 1968)
200 × 190 cm
A Carnets de la Recherche Patiente book (n° 3)
"Layout by Le Corbusier and Jean Petit"
Published simultaneously in French (Paris, Denoël/Gonthier, 1968) and English (The Nursery Schools, New York: Orion Press, 1968)

VARIOUS PUBLICATIONS BY PETIT ON
LE CORBUSIER'S ŒUVRE

L'urbanisme est une clef
Paris: Éditions Forces vives, 1966
125 × 125 mm, 62 pages
A Micro-Carnets Forces Vives book
Republication of the text first published in
1955 (see above)

Le Corbusier parle
Paris: Éditions Forces vives, 1967
125 × 125 mm, 112 pages
A Micro-Carnets Forces Vives book
Republished in 1996 (see below)

Mise au point; l'urbanisme est une clef
Geneva: Archigraphie, 1987
170 × 170 mm
A Cahiers Forces Vives book
Republication of texts first published in 1955
and 1966 (see above)

Robert Doisneau, Jean Petit, *Bonjour Monsieur
Le Corbusier*
Zurich: Hans Grieshaber, 1988
335 × 335 mm, 112 pages
No mention of the Forces Vives imprint, but
strong visual presence of the series image,
notably on the flyleaves

François Vaudou, *La Petite Maison
de Le Corbusier*
Geneva: Carré d'art édition, 1991
210 × 210 mm, 92 pages
Layout by Jean Petit
No mention of the Forces vives imprint, but
reproduction of the tree that served as the
imprint's logo (p. 35)

*BSGDG: Breveté sans garantie du
gouvernement*
Lugano: Fidia Edizioni d'Arte, 1996
210 × 210 mm, 158 pages
A Cahiers Forces Vives book

Le Corbusier parle (a revised, augmented
edition of the Micro-Carnet publication
of 1967)
Lugano: Fidia Edizioni d'Arte, 1996
210 × 210 mm, 144 pages
A Cahiers Forces Vives book

Ronchamp
Lugano: Fidia Edizioni d'Arte, 1996
210 × 210 mm, 150 pages
A Panoramas Forces Vives book

Pino Musi, *Ronchamp*
Lugano: Fidia Edizioni d'Arte, 1996
275 × 275 mm, n.p.
A Panoramas Forces Vives book

SELECTED BIBLIOGRAPHY

GENERAL WORKS ON LE CORBUSIER

Benton, Tim (ed.). *Le Corbusier, Architect
of the Century*. London: Arts Council of Great
Britain, 1987.

Boesiger, Willy (ed.). *Le Corbusier, Œuvre
complète* [1929–1970], 8 volumes. Zurich:
Birkhauser, 1995.

Cohen, Jean-Louis. *Le Corbusier*.
Taschen: Cologne, 2004.

Frampton, Kenneth. *Le Corbusier*.
Hazan: Paris, 2001.

Lucan, Jacques (ed.). *Le Corbusier,
Une encyclopédie*. Paris: Centre Georges
Pompidou, 1987.

Moos, Stanislaus von. *Le Corbusier, L'archi-
tecte et son mythe* [1968], translated by P.-A.
Emery. Paris: Horizons de France, 1971.

BOOKS AND ARTICLES ON LE CORBUSIER'S RELATIONSHIP TO BOOKS, PUBLISHING, AND PRINTING

Brady, Darlene. *Le Corbusier – An Annotated Bibliography*. New York/London: The Garland Publishing, 1985.

Cohen, Jean-Louis. "Le Corbusier: la tentation de l'universel," *Critique* 476-477 (January 1987).

Colomina, Beatriz. *La publicité du privé* [1994], translated by M.A. Brayer. Orléans: Hyx, 1998.

Gabetti, Roberto and Carlo Olmo. *Le Corbusier e l'Esprit nouveau*. Turin: Einaudi, 1975.

Girsberger, Hans. *Im Umgang mit Le Corbusier/ Mes Contacts avec le Corbusier*. Zurich: Éditions d'architecture/Artemis, 1981.

Krustrup, Mogens. *Le Corbusier: L'Iliade, dessins*, translated by M. Christiansen. Copenhagen: Borgen, 1986.

Moos, Stanislaus von (ed.). "Dans l'antichambre du Machine Age" and "Le Corbusier et Loos," in *L'Esprit Nouveau: Le Corbusier et l'industrie*. Zurich/Berlin: Museum für Gestaltung/Ernst und Sohn, 1987.

Morel-Journel, Guillemette. "Le Corbusier's Binary Figures," *Daidalos* 64 (June 1997).

Naegele, Daniel. "Object, Image, Aura: Le Corbusier and the Architecture of Photography," *Harvard Design Magazine*, 1998.

Naegele, Daniel. "Building Books: Le Corbusier's Word-Image Pavilions, an Architecture of Representation," proceedings of the "Medium Architektur" symposium, *Thesis* 3–4, vol. 2 (2004). Wiemar: Wissenschaftliche Zeitschrift der Bauhaus Universität Weimar.

Rüegg, *Arthur. Polychromie architecturale, Les claviers de couleur de Le Corbusier de 1931 et 1959*. Basel/Boston/Berlin: Birkhäuser, 1997.

Smet, Catherine de. "The Book as Urban Metaphor: The Design of *Les Plans Le Corbusier de Paris*, 1956–1922," proceedings of the "Medium Architektur" symposium, *Thesis* 3–4, vol. 1 (2004). Wiemar: Wissenschaftliche Zeitschrift der Bauhaus Universität Weimar.

Vago, Pierre. "Retour aux sources. Le Corbusier et *L'Architecture d'Aujourd'hui*," *L'Architecture d'Aujourd'hui*, 249 (February 1987).

Zaknic, Ivan. *Journey to the East*. Cambridge, Mass./London: The MIT Press, 1989.

Zaknic, Ivan. *The Final Testament of Père Corbu*. New Haven/London: Yale University Press, 1997.

BOOKS AND ARTICLES ON BOOK DESIGN AND PUBLISHING

Chartier, Roger and Henri-Jean Martin (eds.). *Histoire de l'édition française* [1986], 4 vol. Paris: Fayard/Cercle de la Librairie, 1991.

Fouché, Pascal. *L'Édition française sous l'Occupation*, 1940–1944, 2 vol. Paris: Bibliothèque de Littérature Française Contemporaine, Université de Paris, 1987.

Fouché, Pascal (ed.). *L'Édition française depuis 1945*. Paris: Electre-Cercle de la Librairie, 1998.

Jaeger, Roland. *Neue Werkkunst: Architekturen Monographien des zwanziger Jahre*. Berlin: Gebr. Mann-Verlag, 1998.

Jannière, Hélène. *Politiques éditoriales et architecture moderne: L'émergence de nouvelles revues en France et en Italie (1923–1939)*. Paris: Éditions Arguments, 2002.

Jubert, Roxane. "Typographie et graphisme, dissemblances, dissonances… Disconvenance? La France en marge de la révolution typographique," in Isabelle Ewig, Thomas W. Gaehtgens, Mathias Noell (eds.), *Das Bauhaus und Frankreich, Le Bauhaus et la France*, 1919-1940. Berlin: Akademie Verlag, 2002.

Kinross, Robin. *Modern Typography: An Essay in Critical History*. London: Hyphen Press, 1992.

Noell, Matthias. "'Nicht Mehr Lesen! Sehen!' Le livre d'architecture de langue allemande dans les années 1920," in Jean-Michel Leniaud and Béatrice Bouvier (eds.), *Le livre d'architecture*. XVe – XXe *siècle, édition, représentations et bibliothèques*. Paris: Éditions de l'École des chartes, 2002.

Smet, Catherine de. "The Other Side of the Architecture Book"; "Die Andere Seite Des Architekturbuchs," in Elisabetta Bresciani (ed.), *Modern Architecture Books from the Marzona Collection*. Vienna: Johannes Schlebrügge, 2003.

THE AUTHOR

Catherine de Smet holds a Ph.D. in art history, her dissertation having dwelt on Le Corbusier's book production. She is also the author of numerous articles on the history and current state of graphic design and contemporary art. Alongside freelance consultancy, she teaches the history of graphic design in various art schools in France.

This publication is an excerpt from a longer book, *Le Corbusier, architecte du livre* (Lars Müller Publishers, 2005). It is being published to coincide with an exhibition curated by the author, Catherine de Smet, titled "Le Corbusier: The Architect and His Books." At the time of going to press, the venues for the exhibition include:

Centro per l'Arte Contemporanea Luigi Pecci, Prato, Italy: March 20–May 29, 2005.

Museo d'Arte Moderna e Contemporanea– MART, Trento e Rovereto, Italy: June 11–September 11, 2005.

Musée d'Art moderne et Contemporain, Strasbourg, France: November 18, 2005–February 26, 2006.

The exhibition and publication were both made possible thanks to generous help from the Fondation Le Corbusier.

Acknowledgments

I would like to thank all those people at the Fondation Le Corbusier who encouraged and facilitated this dual project of book and exhibition: Secretary General Claude Prelorenzo, Director Michel Richard, and the ever-helpful Isabelle Godinau, Arnaud Dercelles, and Delphine Studer. My thanks also go to the directors of the museums concerned, first of all to Daniel Soutif for his trust, valued support, and decisive involvement; then to Gabriella Belli and Emmanuel Guigon for their attentive handling of the project and finally to Fabrice Hergott, Director of the museums of Strasbourg, who first came up with the idea for this show. I am also grateful to their respective teams, most particularly to Luca Ficini for his terrific photographs.
I would like to express my gratitude to Lars Müller for the enthusiasm he has put into publishing this book, and to his colleagues Mark Welzel and Esther Schütz for their skilled and patient assistance.
Finally, my thanks to Guillemette Morel-Journel for her keen-eyed yet sympathetic reading of the text.

Unless otherwise specified, all documents illustrated here are held by the Fondation Le Corbusier in Paris.

Catherine de Smet

Concept: Lars Müller and Catherine de Smet
Design: Lars Müller
Photography: Luca Ficini/Centro per l'arte contemporanea Luigi Pecci, Prato
Translation from the French by Deke Dusinberre
English proofreading: Andrea Tomcsanyi
Typography: Esther Schütz
Coordination: Mark Welzel
Lithography: Ast & Jacob AG, CH-Köniz
Printing and binding: EBS Editoriale Bortolazzi, Verona

Printed in Italy

ISBN 3-03778-034-7

ISBN 3-03778-052-5 (German edition)
ISBN 3-03778-033-9 (French edition)
ISBN 88-85191-37-1 (Italian edition)

Lars Müller Publishers
5401 Baden/Switzerland
www.lars-muller-publishers.com